AFRICAN SCULPTURE

LADISLAS SEGY

WITH PHOTOGRAPHS BY THE AUTHOR

Dover Publications, Inc., New York

African Sculpture is an original work published
for the first time by Dover Publications, Inc., in
1958.

Standard Book Number: 486-20396-4
Library of Congress Catalog Card Number: 58-5485

Manufactured in the United States of America
Dover Publications, Inc.
180 Varick Street
New York, N. Y. 10014

contents

introduction 1

Some fifty years ago the world of art was elated with shock of discovery. It was suddenly recognized that within the so called dark continent a great art tradition had been flourishing for centuries. And it was observed that this African art anticipated in practice many of the most modern theories of artistic creation and technique.

For quite a while occasional African masks, wooden statues, ivories and bronzes had been filtering back to Europe — the great British expedition on Benin in 1897 alone netted over two thousand bronzes, ivory and wood carvings. But most of this art had been entombed in museum collections and forgotten by all but ethnologists. Europe and America had to grow in aesthetic theory before they could appreciate and understand African art, even though the technical excellence of African bronze casting was immediately recognized.

Today, however, thanks to the Cubist revolution, resulting in an entirely new aesthetic approach to works of art and our modern trend to cultural syncretism, it is no longer necessary to apologize for African art. It is universally recognized as one of the great artistic heritages of the world.

The best African carving, it is commonly accepted, comes from West and Central Africa. It comes from tribes and nations inhabiting a wide swirl from Sierra Leone along

Liberia, Ghana (Gold Coast) and the Ivory Coast, in through Nigeria, French Equatorial Africa, and the Belgian Congo. Its age with very few exceptions is uncertain, since dates are almost meaningless in Africa. The coast of Africa has been moderately well known since the 15th and 16th century, but systematic exploration and occupation of the interior of Africa was closed to Western man until well into the 19th century.

African carving is at once locally diversified according to tribe and locality, and uniform in more important concepts over a very wide cultural area. It was produced by official court sculptors in the great empires of Benin, Ashanti and Dahomey along the West Coast, and it was created by village carvers, sometimes of low caste, in small agricultural settlements in West and Central Africa.

For a really adequate background to African sculpture, it is necessary to explore a dozen different branches of science. The history of the African kingdoms, archeology, ethnology, anthropology, the study of mythology, folklore, linguistics, ethno-psychology, psychoanalysis — all have contributions to make, although in this limited introduction I can indicate only a few important landmarks of the spiritual world in which these carvings lived.

African carvings, I must first emphasize most strongly, were not considered "works of art" in our sense of the term. They were "useful objects;" they were implements used, for the most part, in religious and magical ceremonies which often formed the basis for their social organizations. African carvings had a definite role in the life of the African; without them, in many cases, he could not have functioned in his society; perhaps he could not have survived.

A religious concept provided the theory of which the African carved image is the application. A carved image, for the African, was neither an idol nor an image of God; it was instead, after proper ceremonies, the dwelling place of a "spirit." Spirits were of many kinds. There were spirits of

natural powers — earth, lightning, sun, moon; there were spirits of tribal founders or ancestors or members of the family — in which cases very complex interpretations of "soul" and "vital breath" entered. And there were hosts of spirits who were blamed for all sorts of misfortunes, including sickness.

Behind this concept of "spirits," ethnologists find a meaning: identity and personality have been given to an unknown force. Spirits were "personalization" of forces which the African feared and could not cope with on other levels. And once enrobed with an identity, a spirit became "human-like," with needs similar to those of humans. The spirit became similar to the African, and the African was able to understand him and establish a relationship with him. One aspect of this relationship was a sacrificial ritual: the flesh or blood of an animal was offered to the spirit to feed it. Another aspect could be a gift of something precious to a spirit who had caused a misfortune to ease his malevolence or wrath. Carved objects, shrines, trees, burial grounds, artifacts, mountains — all were embodiments of spirits or dwelling places for spirits. These specific objects or localities enabled the African to localize and "concretize" the spirits, so that he knew how to perform efficient ceremonies and to gain their help.

In our present understanding, we know that spirits do not exist. We know them to be products of man's imagination or projections of his wishes. But the African wanted to find causes or explanations for mysterious phenomena beyond his science, and he wished to be able to control these phenomena. In the spirit concept he found such an understanding and even, in an autosuggestive way, a control technique. This may seem unreasonable to us; this may seem to be circular reasoning: a wish arises; this wish becomes identified with a spirit, the spirit is manipulated to grant the wish. This *is* reasoning in a circle; but deeper scrutiny will also reveal that this is a psychologically effective circle. Very often belief in stern

avenging spirits, sometimes associated with the idea of paternal authority, is based upon an underlying feeling of guilt. With such guilt is associated desire for expiation. In our culture we have self-punishing acts; in Africa expiation could be externalized by sacrifice to spirits, and the individual could regain his sense of security and well-being.

If this background is kept in mind, it is easy to understand that African sculpture was an "instrument" by which the African was able to satisfy deeply rooted psychological needs. Religious and social institutions in turn arose from this basis, and both awarded sculpture an important role in fulfilling these needs.

It is possible to understand why African sculpture carries such urgent emotion to us, even though it comes from a different cultural basis, if we examine the beliefs which caused its rise. The latent motion and the interplay between round and angular shapes (which shall be discussed later) were not invented and used by the African artists primarily to fill his need for artistic expression. They were devised to express his religious beliefs, and are thereby charged with a tremendous potential of emotion. This emotion enables us to "feel" African art, for a work of art or its component parts can be "felt" only if it has been "felt" by the artist himself in the creative process.

The African carver was deeply convinced that his work created a dwelling-place for a power which could help him or his fellows. And thereby he created an overwhelming emotional relationship with an object. So deep a feeling inspired these carvings that if proper artistic talent were applied to them, it became inevitable that the carver's own emotions be incorporated in the carvings. In any work of art of high quality which is the result of the artist's endeavor to express his own feelings, the extent to which these qualities are emotionally communicable depends upon the intensity of the emotion and the "organicness" of its expression. So great, indeed, was the emotional intensity with which the African carver

(and his public) experienced each carving that in our culture we simply have no parallel.

The fact that Western man of the 20th century can feel such an emotional encounter in an African carving raises many varied questions. We capture its message because we can read its plastic language, but what is the emotion which is evoked in us? Can there be a basic emotion shared by both African and Western man? If we simplify our analysis to say that the African carved and used these sculptures to overcome fear of the unknown or known spirits, to protect himself by means of spirits who inhabit his sculpture, can we possibly accept the suggestion that we have remains of such beliefs in our own psyche? Like all psychological questions, this is complex, but let me suggest only one simple illustration.

In our culture, when a child goes to bed and is separated from his protecting mother, he may become intensely frightened. But if he is allowed to hold a doll or a toy rabbit or bear, or something similar, he will often feel that he is not alone, and will sleep peacefully. The child and his parents, of course, do not realize it, but the child's feelings are not too different from the African's. The child is instinctively projecting his wish for protection upon an inanimate object, and in unconscious fantasy is attributing to the object the protective function of his mother. We also know today that many of these emotional impacts experienced in childhood were by no means erased from our psyche when we became adults. Many of our superstitions can be traced to similar infantile animistic beliefs.

Belief in the power of spirits is the basic idea underlying the many rituals which were part of the everyday life of the African. While many of these ceremonies were performed without objects, this discussion will naturally be limited to rituals in which carved objects were used. These rituals can be classified as either religious or magical, although often the two functions were mingled, in which case I shall refer to them as religio-magical.

The African, like many other peoples, believed that the

important transition points in life should be marked by cere-
monies. These are often called "rites de passage," since they
mark passage into different stages of life. The most important
were those of birth, the beginnings of puberty, marriage, and
death.

Although sculptures were used during the entire life
cycle of the African, the most important uses occurred dur-
ing puberty and death ceremonies, which were termed, re-
spectively, initiation and ancestor cult. Birth and marriage
were considered of less importance. The individual is not too
greatly concerned with his own birth, while marriage is more
or less a civil and social matter. Although festivities do take
place in marriage, sculptures were not used frequently.

Puberty, however, and the initiation into male and fe-
male adult society, are the most important acts in an African's
life. He becomes not only an adult, but also a full-fledged
member of the tribe. And death provides the great entry into
the realm of spirithood. During his whole life the African was
dependent upon the spirits of the deceased, and now he himself
will become such a spirit.

Before discussing sculptures used in initiation and the
ancestor cults, I would like, briefly, to indicate a few of the
ceremonials and beliefs associated with childbirth and child-
hood. Among the Ashanti of the Gold Coast, a pregnant woman
might carry the statue called Akua 'ba (Plate 47), "because
its long-shaped neck and beautiful head will help her to bear
a child like it" (Rattray). And among the Bakongo of the
Belgian Congo a statue named Simbu (Plate 81) is placed in
the hut as soon as labor begins, and homage is paid to Simbu
for an easy labor. In the same area a very beautiful "mater-
nity" statue (Plate 85) assures the well-being of child and
mother. Among the Bateke of the Belgan Congo a similar func-
tion is exercised by a statue (Plate 130) which protects the
small child.

The birth of twins aroused different feelings (and dif-
ferent ceremonies) among various African tribes. In many
tribes twins were considered unnatural, and often mother and

children were put to death, although sometimes only the children were killed while the mother had to leave the village. Other tribes, however, like the Yoruba of Nigeria, welcomed the birth of twins, and had a special demigod (Orisha) named Ibeji to protect them. The Yoruba believed that twins shared a single soul. If one twin died, a statue was carved (Plate 49) as a dwelling for the deceased child's spirit. The surviving twin or his mother (if he were too small) performed rituals to the statue as long as the second twin lived.

Puberty ceremonies, however, were much more important than birth or childhood ceremonies, and were very widely spread. They are usually associated with masks, which might be used by the initiate or by the officials of the so-called "secret society." Among the Bapende of the Belgian Congo, for example, a mask (Plate 116) was used on which red coloring had been rubbed. Black raffia was attached for hair, and white raffia for a beard. This mask was worn by the boy, and it was believed that the mask itself represented adolescence. When the mask was thrown away, adolescence was ended.

After the puberty ceremony it was believed that the young man was reborn, but now as an adult member of the tribe. He acquired a new name and a new identity and in some cases had to be introduced to his "former" mother and father again. On a deeper psychological level this ritual is of course easy to undertsand. It meant that the boy's ties with his family were broken, and he was now a separate being. As we know from our own society, if such ties are not severed, the individual cannot function adequately as an adult.

Circumcision was often part of the rebirth ceremony, and after rebirth the new member of the secret society received a small ivory mask (Plate 117) which he wore on a string around his neck. This was his badge of adulthood.

"Ceremonial death" was acted out dramatically among the Sherbro of Sierra Leone, who believed that the "min" or spirit ate the adolescent thereby killing him. The spirit then vomited the candidate. To indicate beyond question that he was newly born, the initiate was washed like a newly born

baby, his head was shaved, and he received a new name.

There were also secret societies for women. Of these the best known was the Bundu of Sierra Leone, which was also known in Liberia as the Sande. In this society the initiated girls wore hood-like masks (Plate 15) and their bodies were clothed in special garments.

In some other secret societies, however, it was not the initiate who wore the mask, but the official of the society. In the Poro Society, for example, each official had a mask (Plate 22). There was a mask for the oath-giver, for the food-collector, for the bearer of the sacred razor, and for others.

The term secret society suggests something mysterious and perhaps illegal to us. But in African society it meant only that the member had to be admitted by ritual and initiation. He learned a special secret language, and was taught tribal customs, the legends of the tribe, and the duties of manhood. What happened in these "bush schools" during the period of seclusion, could not be revealed, especially to women. Far from being outlaw groups, as the Westerner might be tempted to think, they should be considered (at their best) schools for citizenship, social integrating forces, and, upon occasion, bearers of temporal power and justice.

The ancestor cult was the second great religious institution which involved the use of carvings. It had two aspects. One phase was performed at the burial of the dead man; the other during the whole lifetime of the dead man's family.

Among certain tribes, two burials were performed. The first burial was performed soon after the African died. The second burial, which was called the ceremonial burial, took place later, sometimes months later. The reason for delay was usually financial. The ceremonial burial was extremely expensive, and taxed the means of the family, so that funds had to be accumulated. Such a burial was intended to give "proper honor" to the dead man; neglect of this filial duty would invoke the wrath of the ancestors. Psychologically, the meaning of this belief is clear; from childhood on every African was taught to obey and respect his father and the elders. The role

of the father was socially important, and his spirit, when he was dead, stood for codes of behavior. Any supposed infringement of these codes would cause misfortune which, in turn, would be attributed to the wrath of the ancestor. Ceremonies, therefore, were performed to gain the goodwill of the spirit.

Among some tribes of Nigeria masks were extensively used at this ceremonial burial. And in adult secret societies masks were worn at the burial of members, as in the Gelede and Egongun societies of the Yoruba nation (Plate 50). In the Mmo society of the Ibo a special white-faced mask was worn (Plate 55).

The relationship between the African and the spirits of dead members of his family or of ancestors was extremely important to his society, and for this reason many works of sculpture were used in the ancestor cult (Plates 36, 44, 73). Psychological needs, as in the general theory of African sculpture, provided the motivating force for this ancestral sculpture and its ritual. The father had been a prohibiting force upon the individual, and his death did not change the psychological relationship between the father and his subject-children, as can be seen in our own culture. The African believed that the father must continue to give his approval and the rituals of the ancestor cult were designed to win his benediction or approval. Offerings and sacrifices were made to him when he dwelt in the cult statue, and they rendered certain the will of the sacrificers. There was no question of prayer, as in our religions, with the hope that the wish might be granted by God; there was instead a certainty that the wish would be granted if rituals were performed correctly.

Magical ritual differed principally from religious ritual in stressing practical results and emphasizing this concept of certainty. It shared many elements with religious ritual, but it was primarily a sort of primitive "insurance policy": it decreased the hazard of various daily activities. There were such magical rituals for almost all possible occasions: for hunting, healing, divination, obtaining justice, warfare, sowing, harvesting, and so on. The ritual, it was believed, would

bring results. Feelings of insecurity were thereby removed, and faith and self-confidence were established.

Such magical activity benefited the individual and society, and were not only socially acceptable, but socially demanded. They are also sometimes called "white magic," as opposed to "black magic," which was sorcery or witchcraft. Black magic was secret, and was often used for personal revenge. It made use of spells, and at times descended to poison. Sometimes white magic and black magic worked against one another, and the white magician had to discover the identity of the malevolent witch. For this he used divination. The accused person was then forced to undergo an ordeal of poison to prove his innocence or guilt.

Religious and magical practitioners and specialists varied in position and nature from tribe to tribe and area to area, depending largely upon social structure. Various functions could be combined in a single personality, or could be divided among specialists. There might be a king or chief, who was sometimes considered of divine origin, and symbolized the fortunes of his people. There might be a priest or magician, who performed religious or magical rituals. A diviner might investigate the causes of misfortunes, and might foretell the future. There might be an independent medicine man who cured the sick. The witch or sorcerer practiced black magic. And the head of the secret society was often both priest in the puberty initiation ceremony and wielder of justice.

Statues were often used in magic, and many of them can be recognized by a common characteristic: something was added to the statue, nails, beads, animal teeth or magical substances were inserted to give them power. There are, however, exceptions, and to determine which carvings are magical and which are not magical, the student must examine the customs of the tribe that made the statue.

Magic and religion often overlapped. The usual ritual to the ancestral spirit became religious. But when sickness was attributed to the wrath of the ancester, curing the sickness was a magical activity. One of our plates (Plate 101) illus-

trates a small ivory amulet from the Baluba of the Belgian Congo. It was used as a protective amulet, but it was at the same time the abode of the ancestral spirit.

Whether an African carving was religious or magic is really of little importance to an artistic appreciation of it. What is important, and this can be said of any work of art from any time or place, is the artistic quality of the work.

introduction 2

To understand A f r i c a n sculpture you must look at it in the same way that you would look at any other art work of high quality. You must regard it subjectively as a personal relationship, and you must be willing to approach it with as much empathy as you would bring towards meeting a fellow human being.

You may accept a piece of African sculpture as an intellectual stimulant, and you may then question yourself, or your friends may ask, "What does this work of art represent?" "What does it mean?" "Who made it?" "How was it made?" "What purpose did it serve?" All these are valid questions, and I have endeavoured to provide a few answers to them in the first portion of this introduction.

But for you to fully grasp the impact of a work of art, you must develop a second and more important attitude. You must meet it emotionally, and react with an emotional response to it. A piece of sculpture, like any other work of art, can interest us as a unit, or as a summary of coordinated parts, which can be called the plastic idiom of the artist. If the work of art affects us emotionally, we have absorbed the artist's statement, whether consciously or unconsciously. We have captured his message by means of plastic forms, and the sculpture was able to speak to us. If we did not grasp its true meaning emotionally, it would be but a block of dead wood.

To "see" African sculpture, however, you must be open-minded, free of preconceived prejudices about what art should be, and what certain motives and designs mean. To look at a work of art is not enough; you have to *seè* it. One of my aims in this brief introduction is to present points of view to the reader so that eventually he will be able to "read" African carving.

Aesthetic perception, from its very etymology in the Greek *aisthetes*, "a perceiver," refers to visual perception rather than intellectual knowledge. For our purposes this aesthetic perception can be broken down into two divisions. We may compare the object to familiar things. This we call "conventional association." Or, secondly, we may observe the parts of a work and the interrelationships of these parts. This we call "analysis of the plastic parts."

Let us begin with conventional associations, for this approach is the easiest and most immediate for the viewer who has not trained himself to see the plastic qualities in a work of art. It is valid to ask what the overall aspect of African art suggests to the viewer, for it is natural to compare perceptions with familiar artistic or mental patterns. Later I shall discuss analysis of plastic parts, and how they were meant to be interpreted by the African artist and a Western observer. This may involve a conflict in the reader's artistic understanding, for African art very frequently deals with the human body, and to a Western eye the African treatment of parts of the human body may seem exaggerated or even distorted. But let us consider conventional association first.

The first overall impression to strike the Western eye is that African art, especially statuary, is *cylindrical* in form. There are exceptions, as there are exceptions to many of the statements in this brief introduction, but basically it is correct to say that most African art is cylindrical. This is because statues are carved from tree trunks or tree branches. The carver had an intense feeling for the nature and shape of his material, and usually carved within its limits. Often, the African believed that the tree used for his sculpture was the

abode of a spirit, and before cutting it down, a special sacri-
ficial ritual was performed to pacify the spirit of the tree.
What sort of wood was used? It is difficult to say in many
cases, since many African woods are completely unknown in
America and Europe, and we have no name for them. Ebony,
as a rule, was not used, despite the fact that ebony is now
extensively used in objects carved for the tourist trade.

The artist respected the cylindrical form of his tree;
so much so that he often worked his statue into shape from
all sides, so that his work had a wonderful *three-dimensional
quality*. This may sound like a truism, for sculpture by a
definition is three-dimensional, but actually it is not a truism.
In other cultures an artist often paid so much attention to
the front of his statue that other areas were neglected! Not
so the African sculptor. For him the side and the back were
as important as the front. He not only "felt" the nature of
his wood material; he also felt that a good sculpture must have
its own "life" from any angle or side. As a result, if you look
at a good African statue from any perspective, you seem to
see the unseen parts.

This *cylindrical* form, this block-quality, constrained
the African carver to subordinate some aspects of execution
to basic form. *The arms* of African statues, for example, are
usually positioned *close to the body,* although there are ex-
ceptions to this rule in works which come from the Bambara
of the French Sudan (Plate 7), and the Bangala of the North
Congo (Plate 114). If the arms should be separated from the
body, the hands are still connected with the body. This practice
of joining arms and body is not solely an artistic device to
attain columnarity: it also strengthens the statue so that the
arms are not likely to be broken off. It also suggests action
ready to burst forth.

The columnar effect of African statuary causes other
emotional reactions in the viewer: it is as monumental as is
a columned building. How strong this *monumental effect* can
be may be seen in a group of small Warega figurines of ivory
(155–159). Although these figurines are only from three to
five inches in height, they give an overwhelming impression

of greatness, monumentality, and simplicity. Smallness of carving, I might add, never prevented the Warega carver from working in monumental planes, nor did the density and texture of ivory ever tempt the Warega to make intricate carvings out of ivory, as often happened in non-African artistic traditions.

Another result of the African columnar-monumental style is that African statuary usually is *symmetrical* in its component parts. If a line were drawn down the middle of a statue (Plates 7, 114, 159) or mask, left and right sections would be symmetrical. This symmetry also arouses emotional reactions, making us aware of balance and orderly display; these feelings, combined with the monumentality and simplicity already described, give African sculptures the majesty and serenity for which they are deservedly famous.

This columnar shape, the erect posture of the statues, and their rounded heads also have strong *phallic* connotations, which in some statues are further emphasized by a complete neglect of the arms and feet (Plates 77). Phallic symbolism will be discussed later, as an aspect of representation of the human body.

African statues and masks, with a few exceptions from the Yoruba, the Bini, the Bakongo, and other Congo tribes, are *not narrative nor illustrative.* As a rule, they do not tell stories, nor are they engaged in actions which can be identified. This aspect of sculpture can best be illustrated by a piece which does not follow this rule (Plate 51). This represents a man seated upon a horse, and the viewer can immediately understand that the statue represents the action: of riding a horse. Why is he on horseback? In Yoruba mythology the god of lighting, Shango, was also the legendary founder of the nation; and in some manner or other he was connected with a horse. This exceptional piece can serve to suggest two different approaches to the expression of ideas in art: the artist may illustrate action; or he may attempt to express the same idea by "non-illustrative" material. It is one of the great strengths of African sculpture that it "speaks" by sheer use

of plastic shapes and not through actions which suggest associations to the viewer.

Representation of individual parts of the human body is part of the same constellation of beliefs. Position of the arms and legs in African statuary is closely connected with the ideas and techniques which can be seen in the overall aspects of statues and masks. At first glance, these monumental and symmetrical carvings might seem to be static and immobile. But a closer inspection of *the position of arms and legs* reveals a surprising phenomenon. On very many African statues the legs are not straight or relaxed; they are carved in angular, zigzag manner (Plates 120, 131), and tend to be short in comparison with the torso.

What does this position mean? Why not place yourself in the same position and analyze your own feelings? Your reaction, probably, after you have tried this, is that you have to change your position. You must move. And this also means that your impression of the statue is that it is about to move. This incipient movement is further accentuated by the position of the arms, which, most frequently, are not straight and relaxed, but are angular, close to the body, often with hands attached to the abdomen. The stress-positions of both arms and legs remove any appearance of fragility which the piece of sculpture might have had. They also create an impression of *"latent motion,"* even though no motion is actually involved. This is indeed a great artistic achievement.

A lesser artist might have accentuated the movement of arms and legs, and would have "illustrated" an actual motion. This would, for the African, have been over-statement, and the African preferred *understatement.* Such understatement, I must emphasize, is a very important ingredient in true artistic creation. It permits the viewer to place himself in the action and complete it in his own imagination — and thereby enables him to share the creative process with the artist. The viewer is both passive and active: he does not work with materials but he assists by means of identification and imagination in creating the content of the artwork. This

quality of African art recalls a statement by the great French sculptor Maillol, who said of Egyptian sculpture, "The more they appear to be immobile, the more they appear to move."

Just as arms are rudimentary and *feet* sometimes vestigial (because the feet are the least spiritual part of the body), the *head* may be exaggerated in size (Plate 14). Most often this is based on the belief that the head was the place from which the "vital breath" or spiritual power emanated

Cups were sometimes carved as human heads, because of the belief that the head contains vital energy, a belief widely spread in the primitive world. The carved cups replaced the earlier custom of using the skull of the slain enemy as a drinking vessel. The African believed that killing an enemy meant the destruction of his body *only;* that the spirit remained free — a circumstance which allowed for the revenge of the slaying. But if there was ceremonial drinking from the skull-cup or from the carved head cup, they could achieve the total destruction of the enemy (by anihilating the vengeful spirit) and at the same time, the acquisition of his spiritual power (Plate 94-96).

Facial expression of the African statue is also important. A Westerner is often tempted to form an impression of its "mood." He may discover in one statue a "sad" physiognomy, or he may declare that there are no "happy" or "comical" expressions in African art. This, obviously, is entirely pointless analysis, for it is a projection of Western artistic devices which have little or nothing to do with the basic underlying the facial expression of African carvings. Only in a few instances did the African carver attempt to create "visual reality" in his work, or to create an exact portrait of an African. Such pieces of work as Plate 27, with typical Negro facial features, are exceptional. On the whole, since the real purpose of African carving was to create an abode or housing for an invisible spirit, the statues were carved in what may be called "conceptual realism."

To create a reality for the world of the spirits, the African apparently believed that exactly opposite features

must be used from those of living men, since spirits must not
look like living people. For this reason (Plate 32), the nose
on a statue may be long and narrow, rather than short and
broad, and the mouth may be small rather than large and
fleshy. Thus, we may say that what is contrary to visual reality
can become conceptual reality for the spirit. And since the
spirit was an invisible abstract concept, the African used a
non-realistic, spiritualized and *abstract* style to express the
spirit's existence.

This basic symbolism is applicable to the entire carv-
ing, as well as to facial expression or features. In a well known
Bakota (Gabun) funerary figure (Plate 71), the lower dia-
mond shape indicates that the dead man's body has already
disintegrated, while the head, as the abode of the spirit, has
become larger. The statue itself was placed on a basket con-
taining the skeletal remains of the dead man, and it was
believed that the spirit emanated from the statue, its new
habitation. In significance, though not in appearance, these
statues really correspond to the halos which are visible in
early Italian paintings; both represent emanations of the
divine spirit. The native name for this type of statue, indeed,
is "Mbulu Ugulu," which means "picture of the spirit of the
dead."

In some carvings an unusual *coiffure* may attract the
viewer's attention. On a Bateke statue from the Belgian Congo
it resembles a cap (Plate 130), while on an Ibo mask from
Nigeria, it looks like a crest (Plate 55). On a Mendi mask
from Sierra Leone (Plate 15), it looks like a piece of abstract
art. To determine what these forms mean, it is necessary to
examine the customs of each individual tribe. Among the
Bateke the male often shaves both sides of the head, leaving
in the center a crest of curly, crisped hair like the "cap" on
the Bateke statues. Among the Ibo one form of female coiffure
resembles that of the Ibo mask. In each case, however, the
coiffure used in art is highly stylized and exaggerated for
artistic effect.

Colors, too, can sometimes be interpreted by examin-
ing tribal customs. While many carvings are not painted or

stained, quite a few are stained with native dyes to color the originally light-colored wood. On the Ivory Coast, masks were sometimes painted with mud. In some regions white clay was used as a pigment, while among the Yoruba of Nigeria commercial colors of European origin were often used. Very frequently, however, a reddish color, not a pigment or a stain, but a powder called "tukula" was used. This was prepared from a powdered native wood, and was also often rubbed on the body.

The most obvious aspect of distortion and exaggeration lies in the native artist's treatment of the *male and female genitals* (Plates 124, 131), and the umbilicus. The reason for this is fertility symbolism. Procreation and fertility are extremely important in the life of the African. If a wife remains childless, the husband has the right to send her back to her family and demand the return of the bride-price. But this concept of fertility is not reserved for only human sexuality. The fertility of the earth is interpreted sexually; the grain placed in the "mother" earth is fertilized by sun and rain, both of which have male attributes for the African. In some regions of Africa man and wife copulate on the fields during the sowing festivities, thereby connecting the human act with the act of fertilizing the earth. Thus, exaggerated genitals on the statues symbolize both the symbolic meaning of procreation, virility and force. Sometimes a statue has both exaggerated breasts and male genitals, but this does not indicate hermaphrodism, as we might think. Instead, it merely reemphasizes the fertility concept. In good carvings the shape of the genitals is often adjusted to the overall structure of the statue; in Plate 131A, detail of Plate 131 the triangular shape of the phallus parallels the position of the legs.

Visual realism may be abrogated in another way. Facial features on many carvings show both *human and animal characteristics*. The Bayaka mask from the Belgian Congo has a pig's nose (Plate 143); the Poro Society mask has monkey hair attached to a large beak (Plate 23); and the Senufo mask, from the French Sudan or the Ivory Coast,

combines human features with a crocodile jaw, a boar's tusk, and antelope horns (Plate 40). Sometimes, as on the Baule mask from the Ivory Coast (Plate 31), the human face is intact, but horns or figures of animals may be placed above it. Again, the ethnology of the individual tribe — its customs, its myths, its folklore — must be studied before the meaning of these features can be fathomed. In general, however, it is safe to say that animal features have a mythological origin. A widely prevalent myth tells that the founding father of a tribe was helped by an animal when he first came to the territory where the tribe now lives. The animal, in turn, became the protective animal of the tribe, and could not be killed or eaten. This is not exactly classical totemism, however, since classical totemism demands that the tribe be descended from the sacred animal, and that clan members may not intermarry. Such ban on intermarriage within the group — or exogamy, as it is technically known — may be found, however, in some African groups, where it is sometimes associated with a particular deity. The Shango clan in Nigeria and the Dangbe clan in Dahomey are examples of such groups. In the Dahomey clan, the first-born of the priestesses are thought to be the offspring of the sacred snake, but full totemism is still lacking.

On some carvings, such as masks from the Bambara of the French Sudan, as many as eight horns can be found. This is probably for artistic effect: sometimes to conserve the unity of the carving, sometimes to give the carving a more airy effect (Plate 6).

On many African carvings there are *incisions* or *relief* carvings which form geometrical designs (Plate 75). On ivory (Plate 141), these designs may take the shape of an encircled dot. A Western observer may see these designs as pure decoration, but to the African they were functional and meaningful. The small incisions or relief patterns often indicate scarification marks, either tribal identification or body ornament (Plate 75). The circle-dot symbol indicates the sun (male power) and vital energy (the dot); it increases the power of the small ivory carvings. And on many Bakuba ceremonial cups and goblets from the Belgian Congo there are elaborate

interwoven patterns, which may seem to be purely decorative, but actually, each pattern has its name and meaning.

In some statues,, as in the Bateke piece in Plate 130, there is a *cavity* in the abdomen. Here a box or piece of skin was attached to the body, for wherever there are cavities, there were once magical substances, now lost. Occasionally, however, the box with magical substances is still attached (Plate 82). These *magical substances* were added by the priest to consecrate the object, to imbue it with the power sufficient to make it serve the purpose for which it was made. Occasionally, as on some Basonge statues, a horn was placed inside the head (Plate 121). In such a case, the horn contained the magical substance, and often the horn filled with magical material was used independently as a protective amulet. Sometimes oil was rubbed onto the carving, as on the Pangwe statues (Plate 73), or on the small ivory amulets of the Baluba (Plate 101), and sacrificial blood was poured over the carving. All these rituals were intended to empower the object with increased magical strengths. On some statues, especially those of the Bakongo tribe of the Belgian Congo, the magic box was sealed with a mirror (Plates 81, 82), and sometimes the eyes, too, were made of small pieces of mirror. These mirrors appear to have been apotropaic in function: they reflect the sun in a blinding ray, and drive away the malevolent spirits that cause sickness and misfortune.

Other materials might be added to African carvings: carpenters' nails, (Plate 121), necklaces made of beads or animal teeth, cloth, cowry shells, and similar objects (Plate 118). Animal teeth added the power of the animal (strength, cunning, etc.) to the statue, while cowry shells, from their resemblance to female genitalia, were fertility symbols. They added power to the statue, and fostered fertility. These cowry shells, surprisingly enough, were not found in West Africa, but were imported from the East Coast and the Indian Ocean. At a later date they were used as money in Central Africa.

The addition of this material, sometimes of non-African origin, poses a question which often occurs to the viewer:

does the addition of definitely European material to a statue detract from its genuineness? The answer, in most cases, is no. Since the 16th century cultural exchange had taken place between Africans and Europeans, and trade articles from Europe were frequently incorporated into African art. Nor did the art suffer. But when actual European penetration undermined the ideological background for carving, the artwork degenerated. This, however, is from lack of impetus, not from contamination with European materials.

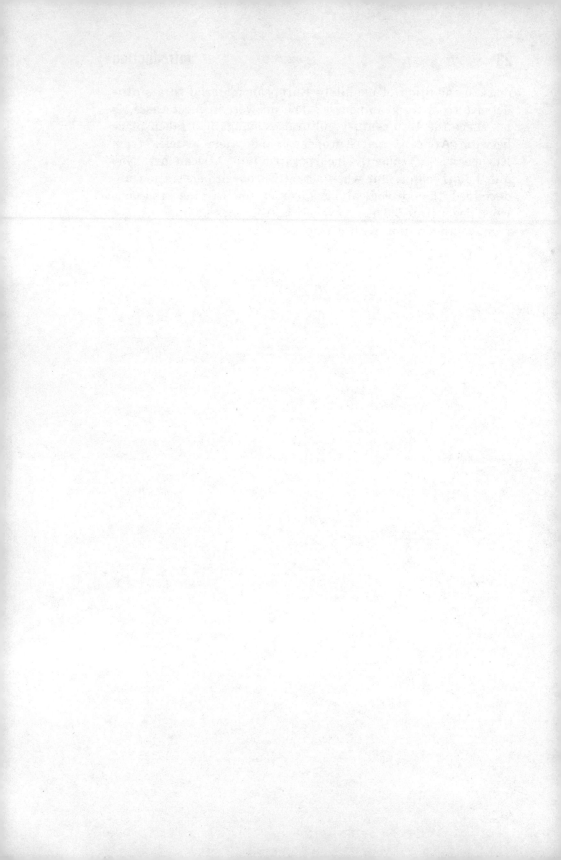

introduction 3

This summary discussion
of the more common "distortions" of the human body in Afri-
can art should indicate that every detail had a meaning for
the sculptor. But this is not the only role which detail plays
in African sculpture: detail is also part of a plastic construc-
tion which is the work of art itself.

When you first saw a piece of African art, it impressed
you as a unit; you did not see it as a collection of shapes or
forms. This, of course, means that the shapes and volumes
within the sculpture itself were coordinated so successfully
that the viewer was affected emotionally.

It is entirely valid to ask how, from a purely artistic
point of view, this unity was achieved. And we must also in-
quire whether there is a recurrent pattern or rules or a plastic
language and vocabulary which is responsible for the powerful
communication of emotion which the best African sculpture
achieves. If there is such a pattern or rules, are these rules
applied consciously or instinctively to obtain so many works
of such high artistic quality?

It is obvious from the study of art history that an
intense and unified emotional experience, such as the Christian
credo of the Byzantine or 12th or 13th century Europe,
when expressed in art forms, gave great unity, coherence, and
power to art. But such an integrated feeling was only the in-

spirational element for the artist, only the starting point of the creative act. The expression of this emotion and its realization in the work could be done only with discipline and thorough knowledge of the craft. And the African sculptor was a highly trained workman. He started his apprenticeship with a master when a child, and he learned the tribal styles and the use of tools and the nature of woods so thoroughly that his carving became what Boas calls "motor action". He carved automatically and instinctively.

The African carver followed his rules without thinking of them; indeed, they never seem to have been formulated in words. But such rules existed, for accident and coincidence can not explain the common plastic language of African sculpture. There is too great a consistency from one work to another. Yet, although the African, with amazing insight into art, used these rules, I am certain that he was not conscious of them. This is the great mystery of such a traditional art: talent, or the ability certain people have, without conscious effort, to follow the rules which later the analyst can discover only from the work of art which has already been created.

Let us start with the way that the African used shapes and combinations of shapes. There are "recurrent patterns," one of which, repeated on many carvings, consists of an *interplay of round and angular shapes*. This plastic configuration causes a feeling of tension in the observer; there is a stress or strain about such forms, and you get the feeling that "something is about to happen." This reinforces the same feeling of action-in-embryo which arises from leg and arm position. The work of art as a whole radiates tension and is extremely powerful.

All this is simply a rewording of a discovery of Cezanne's, which I have tried to adapt to African art. This adaptation, strange though it may seem at first, is not really forced; African art and the Cubists shared much.

After Cezanne, the great innovator of our day, had "realized" (to use his own expression) a number of paintings, he tried to explain the inner metabolism of his work. In one of his famous letters he wrote that a painting can be con-

structed upon the basis of cones and spheres. A cone represents two straight lines meeting at an angular point with a round base and the sphere is perfectly round. If the cone is dissected, it becomes angles, and if the sphere is slashed through the middle (or in sections), it becomes an infinity of roundnesses. Angularity and roundness are the recurrent motifs of African art.

Suppose we illustrate the recurrence of round and angular forms. One of the simplest statues in our plates is the Azande columnar statue (Plate 77), which is cylindrical except for the angularity in the middle. The same interplay of round and angular shapes can also be observed in the head of the statue. Plate 153, a wooden statue of the Warega, shows the same principle. Here, however, the interplay of angularity and roundness is markedly strengthened by the shape of the chin and the form of the legs. Both this statue and the Azande statue are obviously phallic.

The Ouobe-Guere mask from the Ivory Coast (Plate 30) is very boldly constructed. It consists of three large masses: forehead, nose, and mouth. The upper parts of all three are round, but each is bisected by a straight line, which forms great dramatic contrast between curves and straight lines.

The Bambara antelope from the French Sudan (Plate 2) is even more complex. Again, three round shapes can be distinguished: the horns, the body of the antelope, which is boldly abstracted, and the lower animal, which is an anteater. Angular features are abundant: I need point out only the three horn-like fixtures on the top, the zigzag pattern indicating the body of the antelope, and the anteater's legs.

I have selected only four very simple examples demonstrating the interplay of roundness and angularity on typical sculpture. This same relationship can be observed on very many African sculptures, although occasionally it is necessary to analyze forms very closely to see this interplay. These forms are recurrent patterns, part of the vocabulary of the African artist. But what do they really mean? What emotions do they arouse in us?

To discover the inner mood of the contorted legs frequently seen on African statues, I recommend that the reader place himself in the same position. But a test on this obvious level will not solve all such problems, for the average viewer cannot dissect himself mentally into an arrangement of cubes and spheres. But there are other techniques for attaining such knowledge, and I contend that shapes and forms and even colors have such *inherent emotional qualities' of connotation and evocation.* We experience definite feelings when we encounter such objects, even though our feelings may arise from an uncounscious level, and we may not understand them. Our individual attitudes, however, may be colored by feeling associations which have arisen in our lives, especially during childhood.

Round forms, especially when related to the human body, suggest female attributes: breasts, hips, pregnancy. Our own first experiences were with the female body, we must remember, and we know today, from clinical evidence, how important these childhood experiences are. And, laden with emotion, they acquire even greater importance if for one reason or another they were repressed in our uncounscious. Contemplation of shapes similar to parts of the female body might evoke repressed feelings in us without ever having been conscious of them. And it is equally possible that our associations may be within the realm of conscious thought.

It is curious to note at this time that the first carvings which man made were Ice Age statues carved, perhaps, anywhere between 20,000 and 30,000 B.C. Apparently fertility statues, they represent women with enormous breasts and hips which are probably exaggerated for symbolic reasons. From a purely plastic point of view these shapes are round, and this equation of roundness with softness, femininity, and similar concepts seems as old as man.

The emotional associations of angular shapes are not as direct as those of round shapes. The first association which comes to mind is the erect position of the male genital organ. Dream analysis has shown that any angular object, especially

knives, sticks, and weapons have male connotations. Angularity also suggests aggressiveness, the very opposite mood to softness of undulant shapes.

For purpose of exposition, I have separated round and angular forms from one another, but they are usually combined, and their interplay — of male and female — indicates at once opposition and attraction, or a union of opposites. This can further be translated into the dynamism of opposition and attraction of wishes and desires, and into the tension that exists between the two sexes until they find gratification.

In my preliminary remarks I stated that African sculpture in general, in overall aspect, gives an impression of great serenity and apparent calm. And I do not intend to contradict this. Instead, I am only reaffirming the power of the African artist to show in the very same carving the struggle between opposite forces, and at the same time unite them into a compact unity. The tension between the symbols of two sex-forces seems to be consummated in the overall aspect of African sculpture; tension is released and unity attained.

This is a very great artistic achievement, for, in addition, the display of round and angular shapes may also be interpreted as indicating the inner storms of a life-struggle, or the forces which mold the individual. It would appear then, that after a solution is found and the tension released, peace and balance are achieved. According to the psycho-analytic point of view, a work of art is a way of gratifying unsatisfied wishes, and often is the expression of strong but repressed sexual drives.

It is often said that African sculpture influenced *modern art*, especially the pre-Cubist and Cubist movements. Study of documents about the "rediscovery" of African art, and discussions with Picasso, Braque, Gris, and other Cubists have convinced me that this is only a half truth. Cezanne, who never saw African art, laid down the basic principles upon which the Cubists began to create their own work. Besides the concept that a work of art could be constructed out of plastic elements — cones and spheres — Cezanne also recog-

nized that the work of art should be or could be independent from visual reality. As Picasso so well formulated it: "When the form is realized, it is there to live its own life."

African masks and statues were on exhibit in the old Trocadero Museum, or were sold in curio shops. And it is not unnatural that artists who were evolving new concepts, upon seeing these African carvings, found to their astonishment that what was new to them had actually been familiar to African artists for many hundreds of years, and became enthusiastic about African art. Indeed, the credit for the recognition of African art as art and not as ethnological specimens is due to these Parisian artists. We may carry this one step farther and say that our own modern ability to see African sculpture as great art is due to these European artists and to the assimilation of their new aesthetic standards.

The important historical fact, however, is that while the rediscovery of African art confirmed the researches of the Parisian group, it did not "cause" Cubism. The Cubists had already been working in the same area, although without doubt the African impingement *encouraged* them to believe that their path was a true way. But African influences cannot be wholly ruled out in all cases. Such artists as Modigliani, Barlach, Ensor, and Klee may well have been directly influenced by the "formal" aspects of African work, but the great affinity between Cubist work and African work lies, instead, in plastic construction.

To return to African sculpture: even though there is a general plastic style for African art, there are still specific "recurrent" styles for various tribes and culture areas. Thus, Pangwe statues (Plate 73) are composed predominantly of bulbous shapes. especially visible in arms and legs; Dogon masks from the French Sudan are constructed of squares or triangles; and Baule statues from the Ivory Coast have finely incised hair-dressings. Such tribal characteristics, though obvious to the student, do not distract from the overall effect and plastic construction which all African art shares. They simply enable us to classify some 200 styles in West and Central Africa.

Why did each tribe have a *distinct style,* even though it may have had close trade and cultural relations with its neighbors? The answer probably lies in ethnocentrism: each tribe believed itself to be different from or even superior to others. Each tribe took pride in its ancestors, and like primitive peoples from other parts of the world, referred to itself as "the people", thereby inferring that others were not people. As a result of this conservatism and the intense disciplining of the gifted young African who apprenticed himself to become a sculptor, tribal styles could be kept intact for centuries. They served as symbolic expressions of the superiority of one's home tribe. Yet change could occur, and patterns and designs and shapes could be diffused by peaceful or warlike means. Traders could carry new ideas through the forests of West Africa, and a conquering tribe, assimilating its newly subject population, might find artistic ideas worth copying.

Yet even though there is such a tribal style for each people, no two pieces of art work are like. Within the strong discipline of distinct tribal styles there was also room for the variation which emerged from the personality or talent of the carver as individual artist. Such individual variations are extremely important from the collector's point of view, for the collector is usually primarily interested in artistic quality.

Each piece of African art, like other specimens of traditional art, is a symbiosis of individual talent and tribal form. The individual conformed, basically, to the tribal art pattern for the same reason that he conformed to the beliefs, customs and taboos of his people. He was forced to. He may have lost a certain amount of individual freedom, but when he accepted the communally shared ideology, he gained a feeling of oneness with his group and a feeling of security. When he followed traditional art styles, he walked in the ways of his ancestors.

But when European man came to Africa with gun and religion and trade goods, and conquered the area which produced the best African art, the ancestral ways were largely destroyed or neglected. A new monetary system, new industries, conscription, taxation, forced migration, new ideas,

"modernism", Western amusements — all contributed their share to undermining the traditional culture of Africa. The carvings which were produced after this cultural conquest reflect such changes. They no longer have the homogenity of style and workmanship which characterized the old work. European art-teaching European artifacts caused a demand for naturalistic work; a tourist trade created a chaos of mechanical or meretricious ornaments. There are still talented African carvers, but the great tradition of African carving now lies in the past.

conclusion 4

There are two important elements which the viewer must grasp to understand African sculpture. These are the CONTENT and the EXPRESSION.

The content is a deeply felt emotional experience (religious or magical), which is based upon psychological needs. And because African sculpture can fullfill these needs, it is not an "art work" in the Western sense, but a ceremonial artifact which helps to "act out" these beliefs. Because the psychological dependence upon the carving is very deep, and, indeed, inspired the carving, the forms used by the "artist" are imbued with deeply felt emotion.

Expression, on the other hand, is the actual infusion of this religio-magical faith into the piece of sculpture itself. Here the talent of the individual artist, a long cultural tradition, an instinctive feeling for forms and materials all interplay, and the result may be a high quality work of art which can stand by itself without a cultural background.

These two basic elements were fused in African art, and the African was able to express his deeply felt emotional experience in a fully coordinated and disciplined manner. Western man, on the other hand, is able to feel the communicative quality of the African's artistic expression, and, in turn,

its emotional content. The work is the result of a deep psychological need to unload tension, and the viewer from another culture, if he is able to "read" the plastic language, undergoes, by identification, the same feeling of release of tension.

This magnificent coordination of content and expression, the incredible organic relationship of sculpture to psychological needs, places African sculpture among the great art traditions. It is the aesthetic quality, the meaning of form and coordination and communicative quality which is our first interest in the study of African art. And this can be obtained by sheer contemplation of the work itself. But determining the nature of our aesthetic feelings, satisfying our intellectual curiosity about the background of the artistic object we admire, is an entirely different matter.

Here is where the great excitement in the study of African art lies. Not only does the viewer have a great emotional reaction; he can also satisfy his intellectual curiosity by studying the extensive material about African culture. It is hoped that this introduction will call attention to the rich and varied possibilities which await further contact with African sculpture.

PLATES

FRENCH SUDAN

1. Antelope headgear. Bambara, French Sudan. 37″ high.

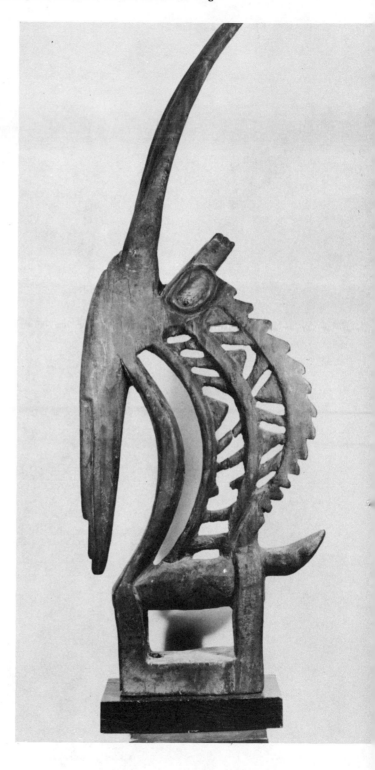

2. Antelope headgear. Bambara, French Sudan. 18½″ high.

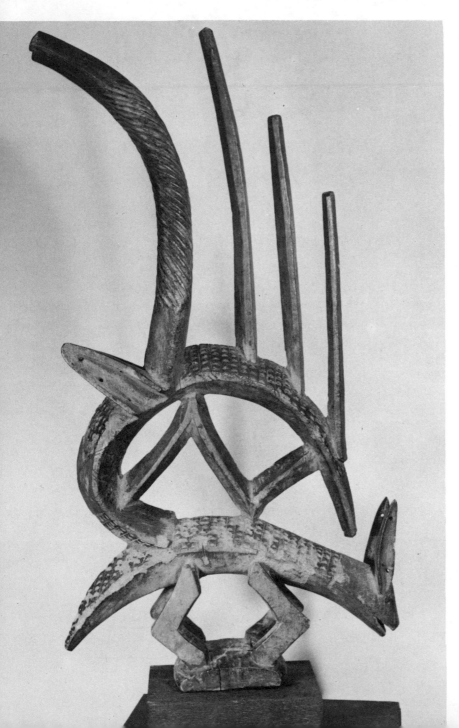

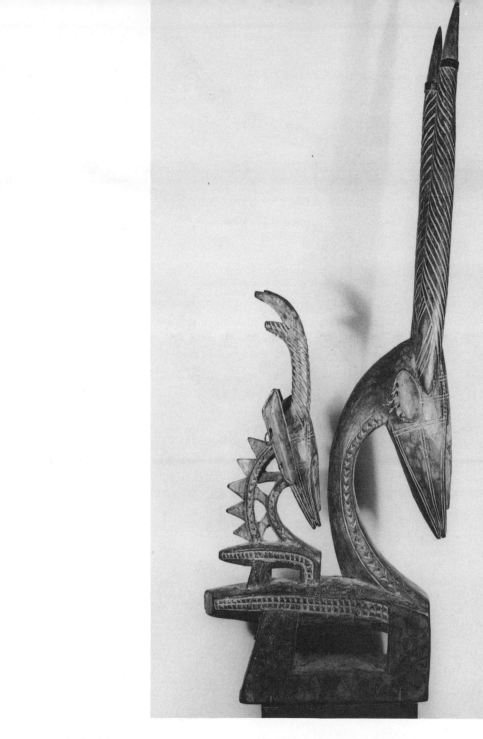

3. Double antelope headgear. Bambara, French Sudan. 31″ high.

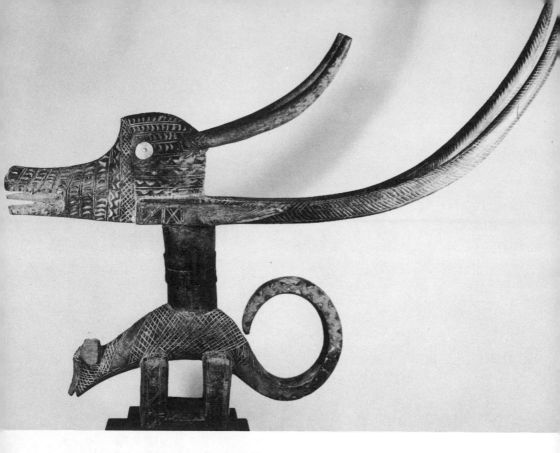

4. Antelope headgear. Bambara, French Sudan. 13¼″ high, 23″ long.

5. Mask with horns. Bambara, French Sudan. 27″ high.

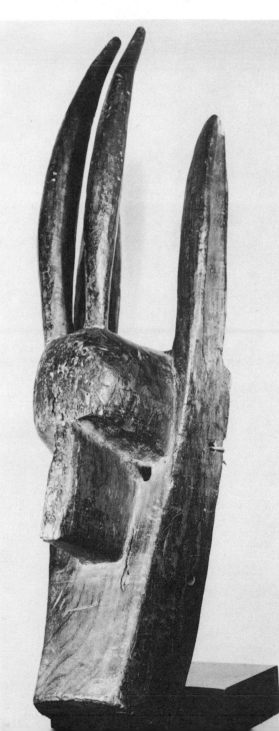

6. Horned mask with cowry shells. Bambara, French Sudan. 20″ high.

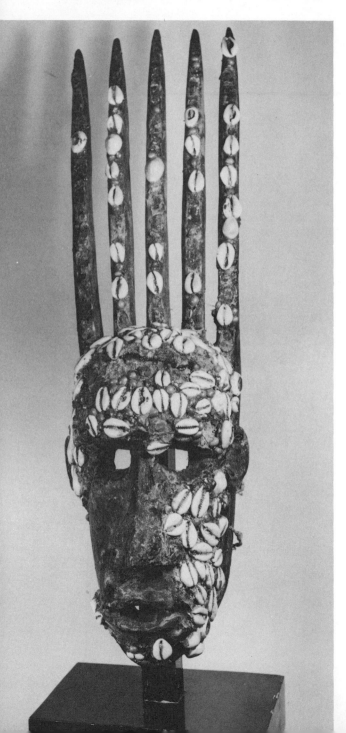

7. Statue with colored beads. Bambara, French Sudan. 12″ high.

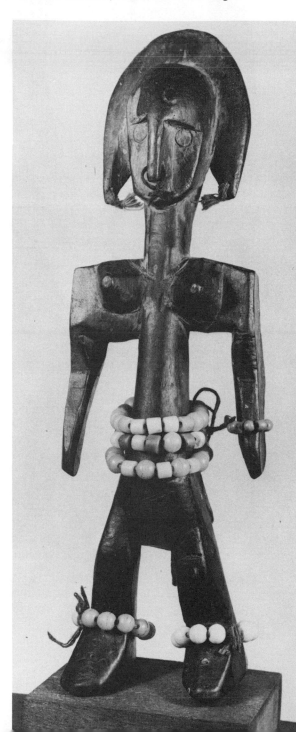

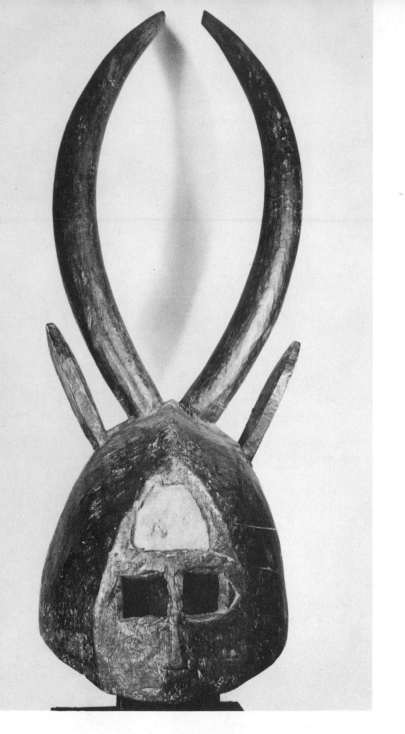

8. Hood mask. Bambara (Mopti region), French Sudan. 23″ high.

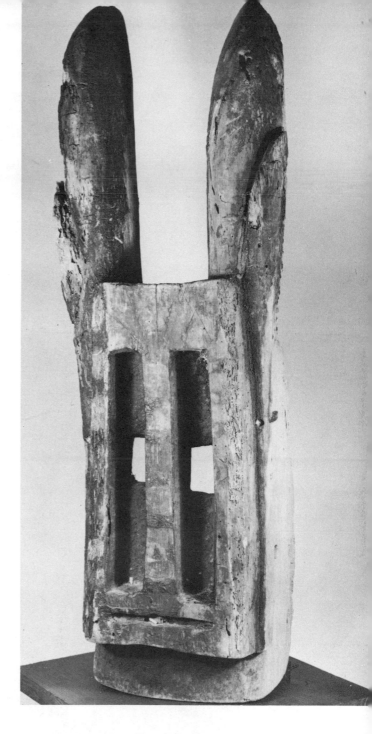

9. Burial ceremony mask (Walu, the antelope), Dogon, French Sudan. 27″ high.

10. Burial ceremony mask (Kanaga, the bird). Dogon,
French Sudan. Detail: 12½″ high.

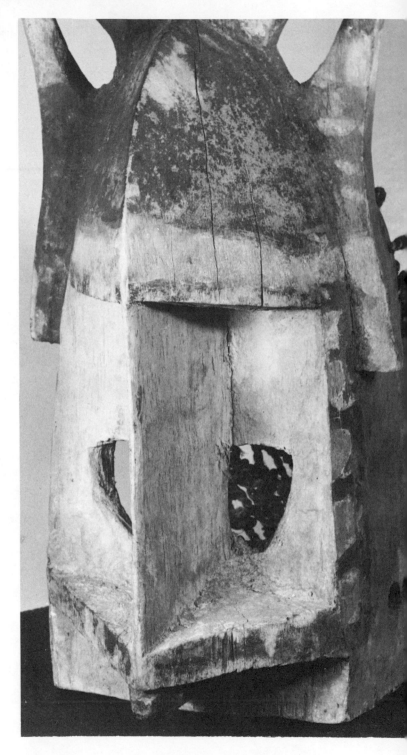

11. Bird mask, polychromed. Bobo, French Sudan. 13½" high.

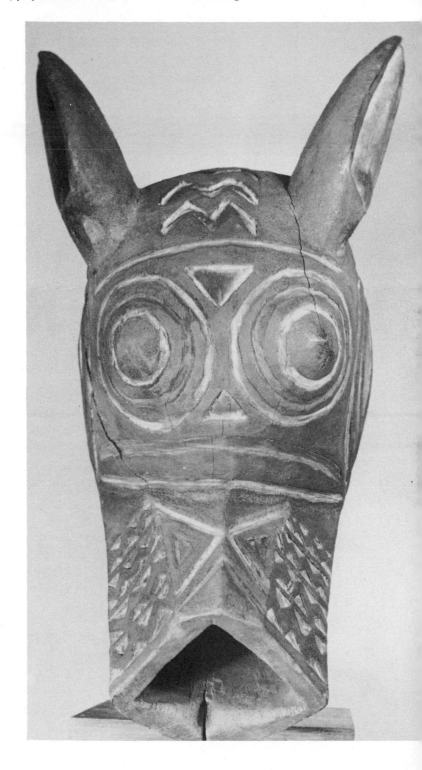

12. Statue representing Ariza, the malevolent spirit.
Region of Black Volta. 7″ high.

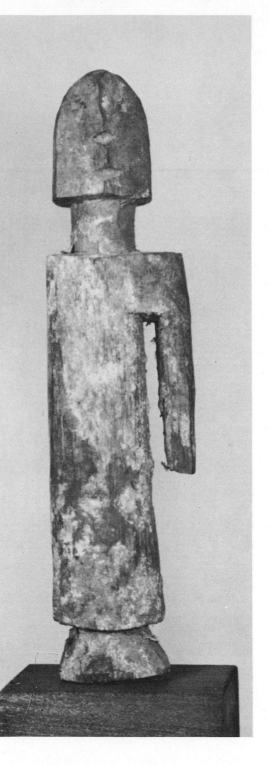

13. Statue, representing Arbor, spirit of water.
Region ot Black Volta, 7½″ high.

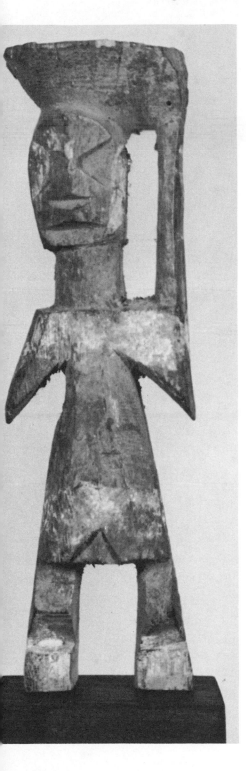

FRENCH
GUINEA

14. Simo secret society statue, Baga, French Guinea. 14″ high.

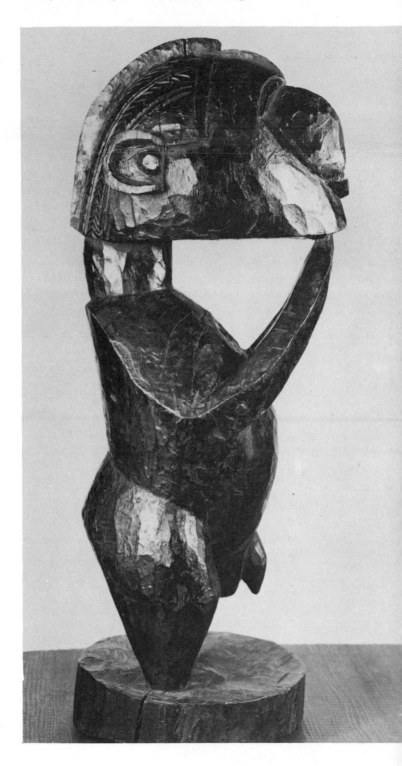

SIERRA
LEONE

15. Bundu female secret society hood mask. Mendi, Sierra Leone. 16″ high.

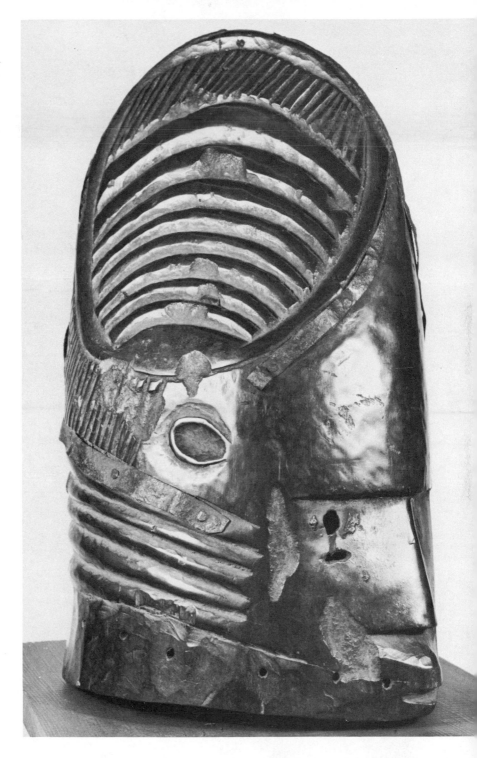

16. Statue. Mendi, Sierra Leone. 22″ high.

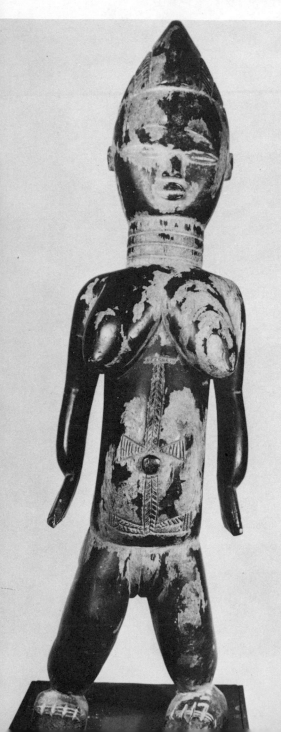

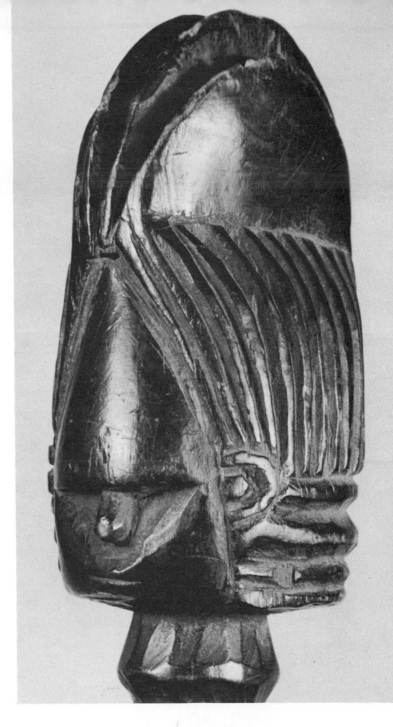

17. Head of an oracle figure. Mendi, Sierra Leone. Detail: 4½″ high.

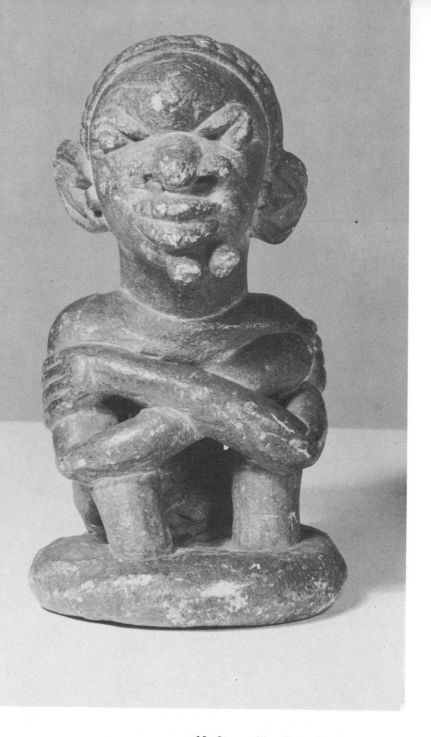

18. Stone effigy (Nomori). Mendi, Sierra Leone. 8″ high.

19. Horned mask. Toma, Sierra Leone. 26″ high.

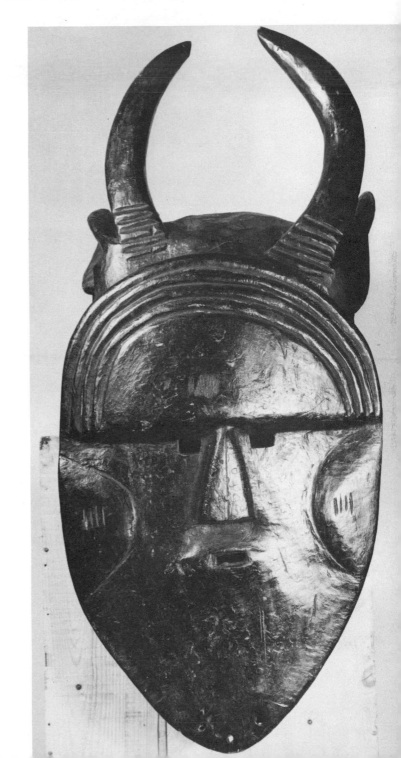

LIBERIA

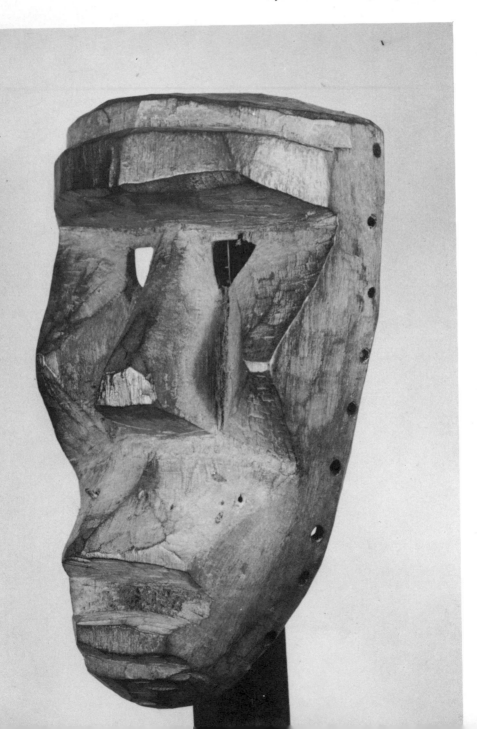

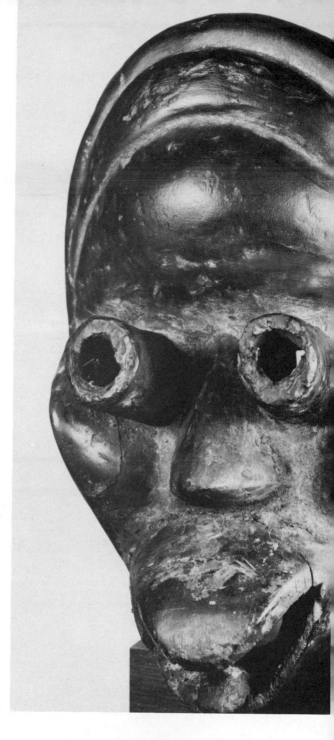

21. Poro secret society mask. Mano, Liberia. (Similar
style also Guere-Ouobe, Ivory Coast). 11½″ high.

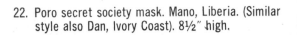
22. Poro secret society mask. Mano, Liberia. (Similar style also Dan, Ivory Coast). 8½″ high.

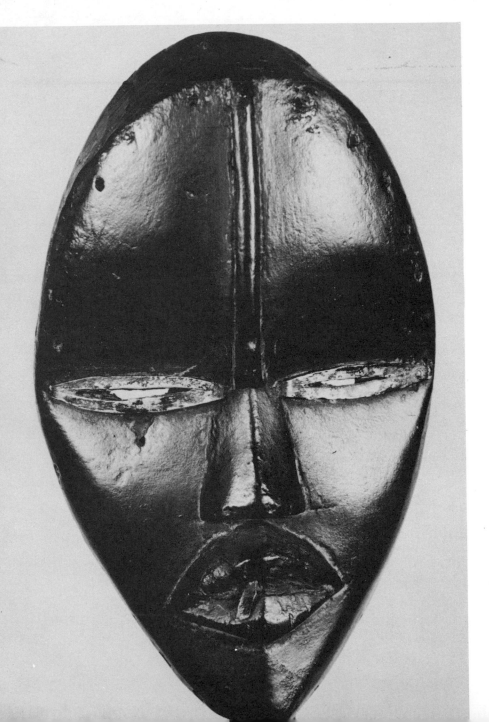

23. Poro secret society mask. Geh, Liberia. 10″ high.

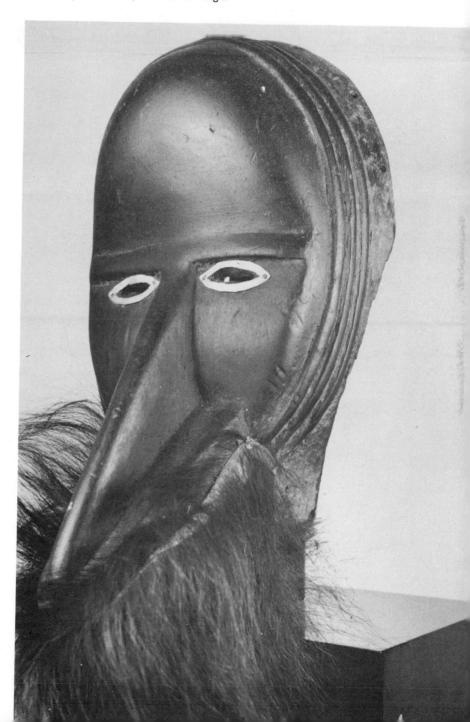

24. Poro secret society mask. Geh, Liberia. 8½″ high.

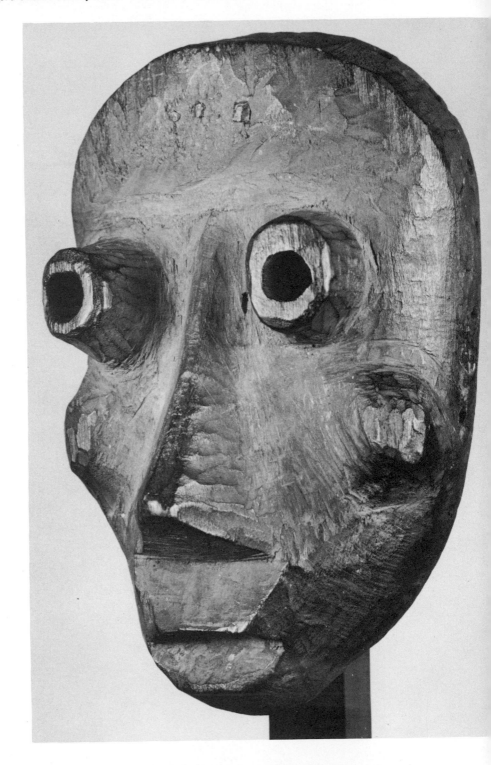

IVORY
COAST

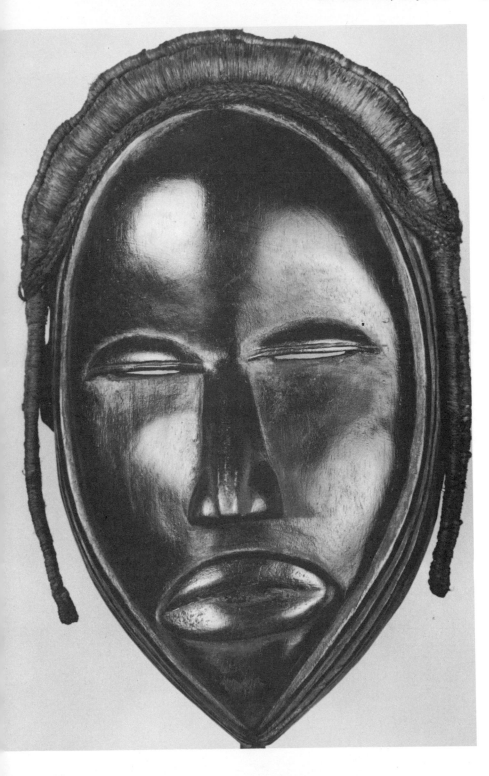

26. Mask. Dan, Ivory Coast. 9″ high.

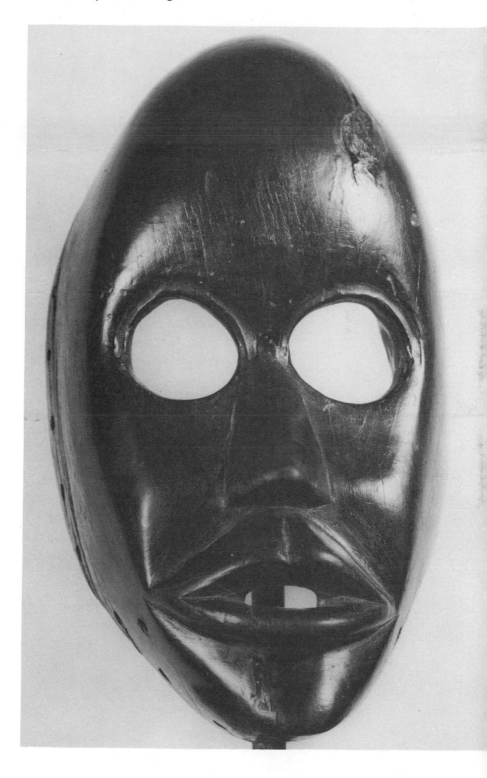

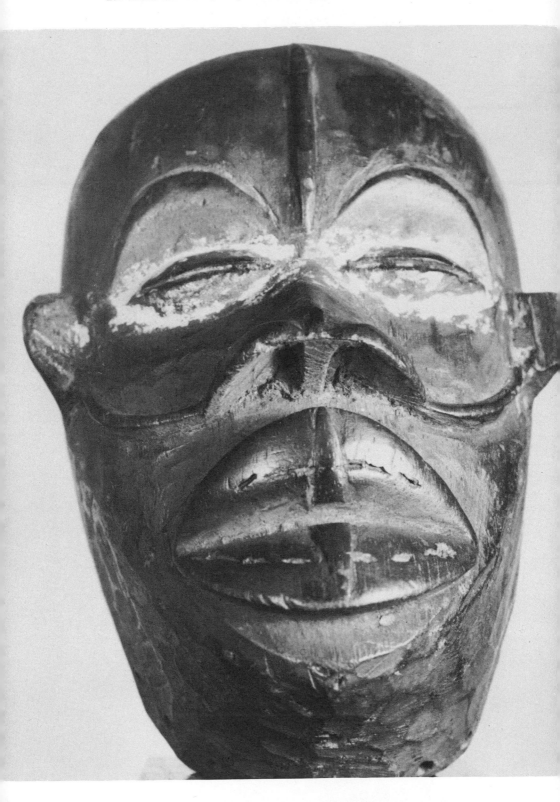

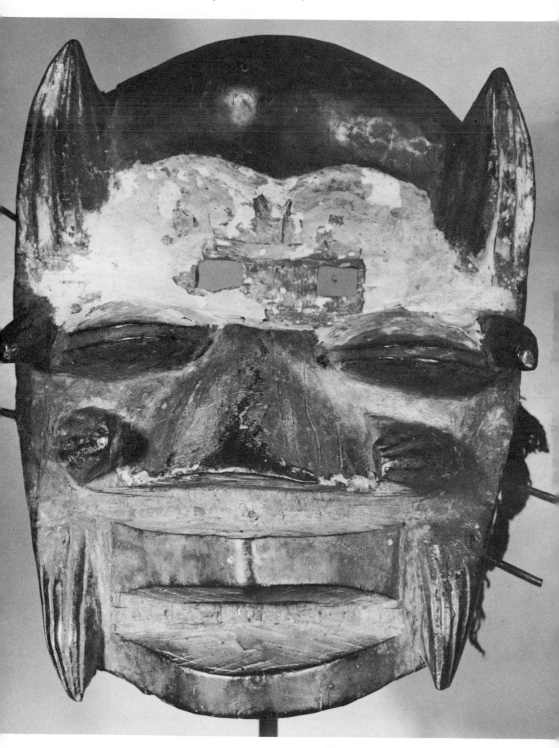

28. Mask. Guere-Ouobe, Ivory Coast. 11½" high.

29. Mask. Guere-Ouobe, Ivory Coast. 12″ high.

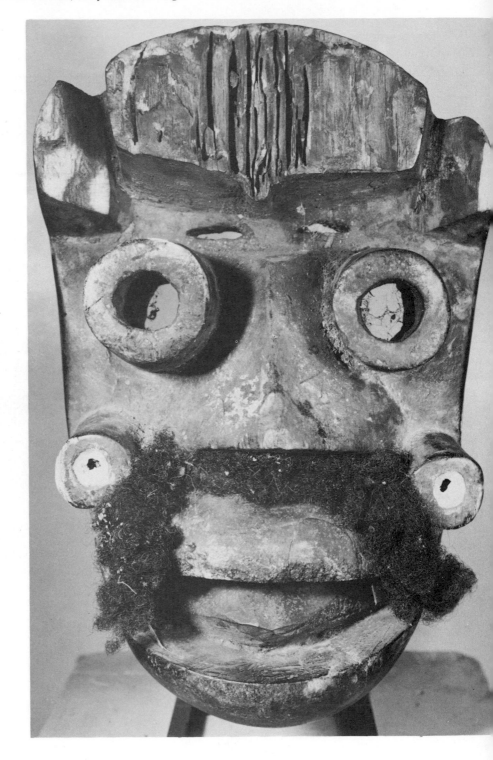

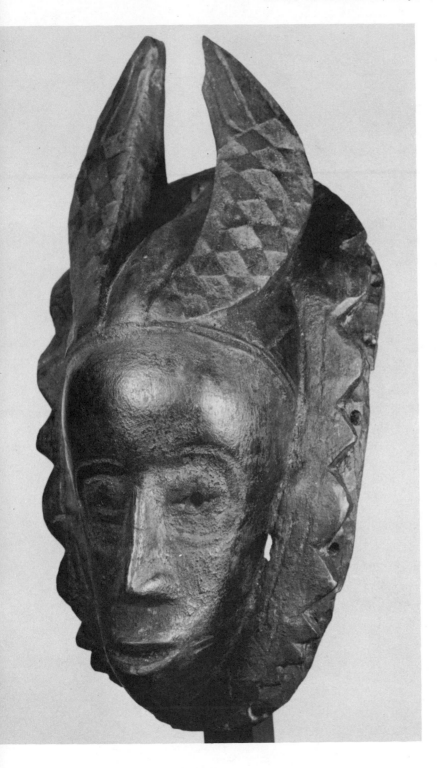

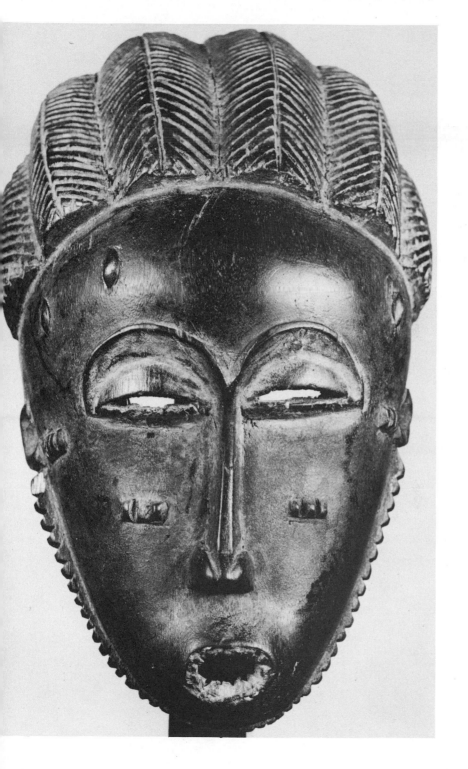

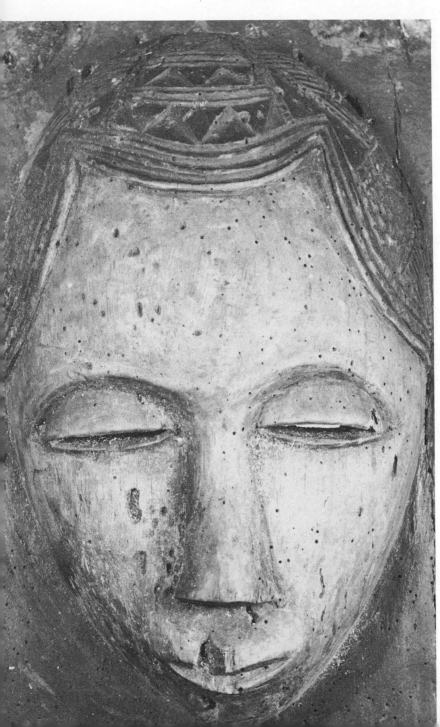

33. Mask, part of a plaque. Baule, Ivory Coast. Detail: 8″ high.

34. Head of a ram. Baule (Region of Bouafle), Ivory Coast. 11″ high.

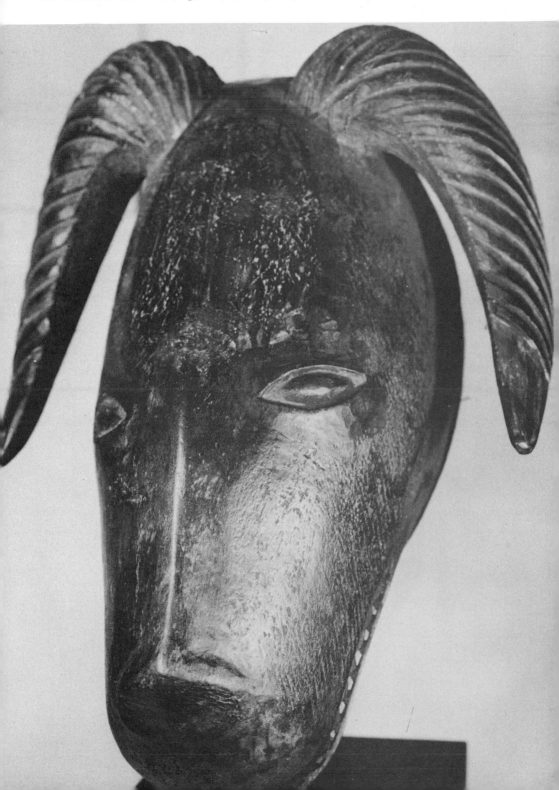

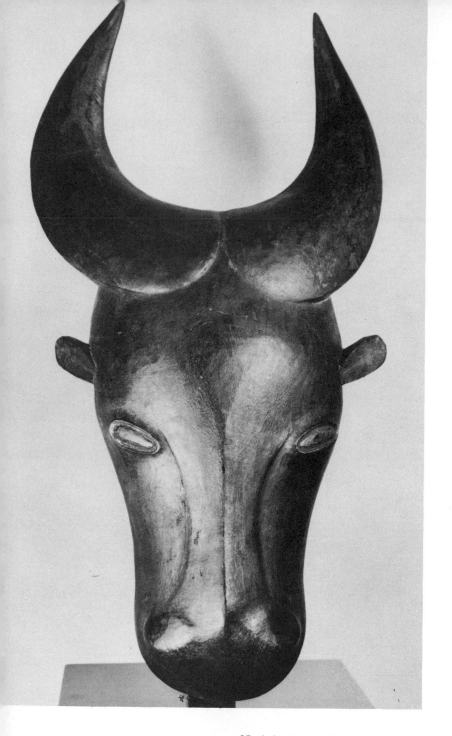

35. Animal mask. Baule-Guro, Ivory Coast. 16″ high.

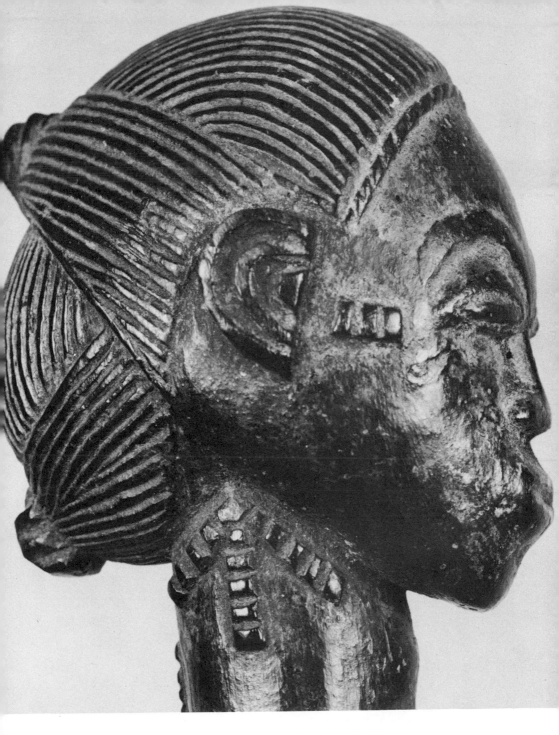

36. Head of an ancestor cult statue. Baule, Ivory Coast. Detail: 4″ high.

37. Musical instrument. Baule, Ivory Coast. 7″ high.

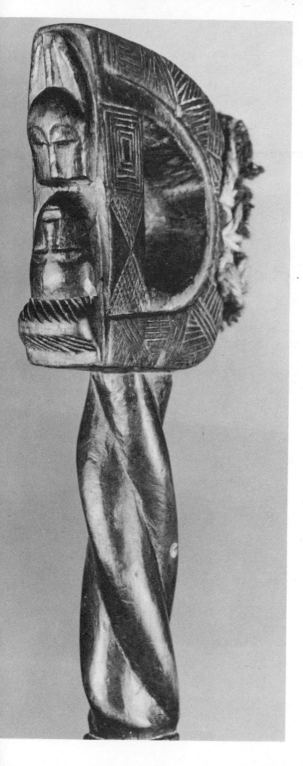

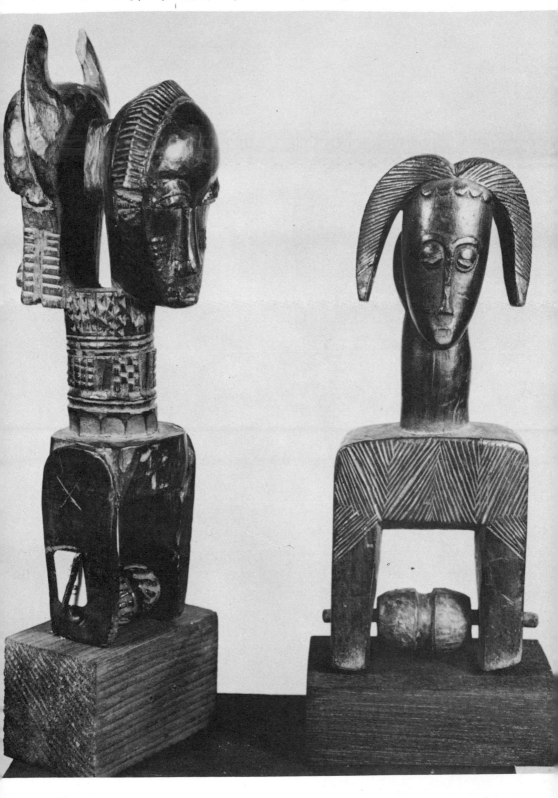

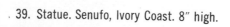
39. Statue. Senufo, Ivory Coast. 8" high.

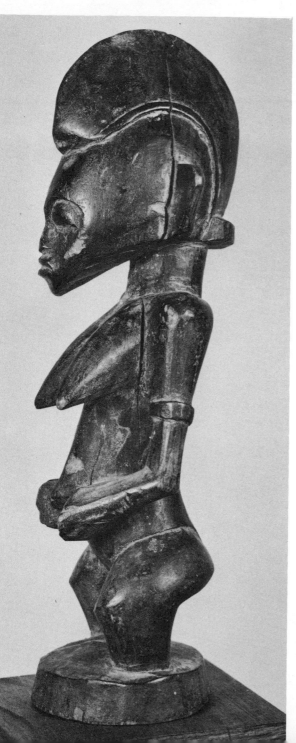

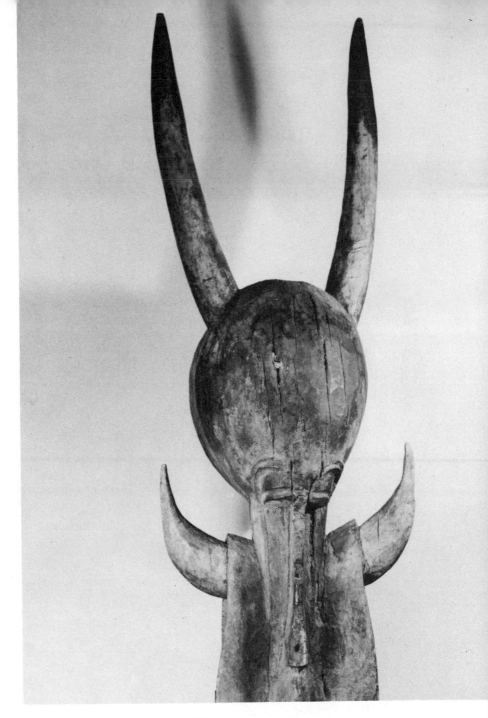

40. Funerary mask. Senufo, Ivory, Coast. 31″ high.

41. Statue. Senufo, Ivory Coast. 13″ high.

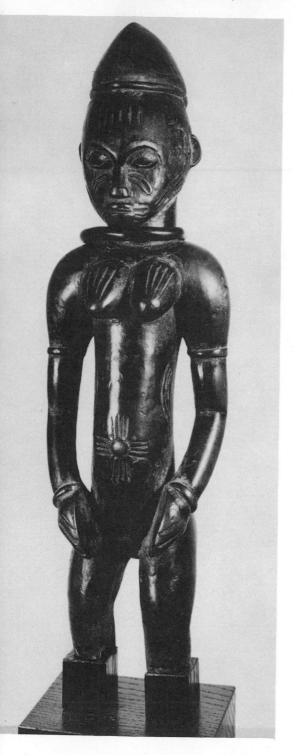

42. Mask. Senufo (Korhogo Region), Ivory Coast. 16″ high.

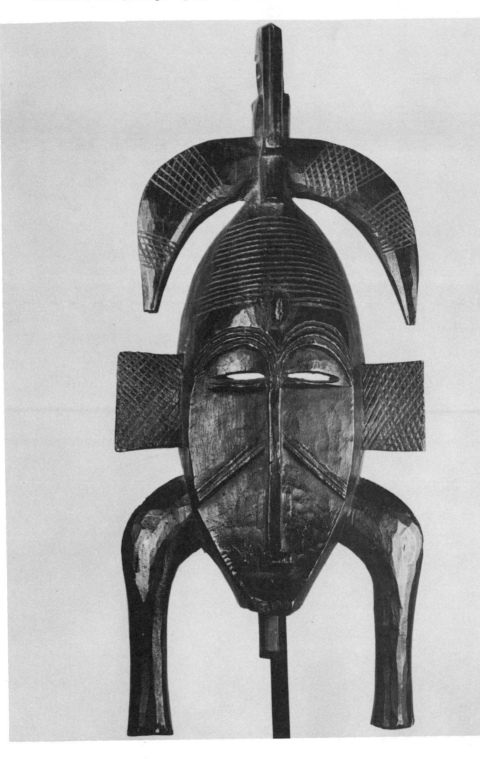

43. Warthog mask. Senufo, Ivory Coast. 20″ high.

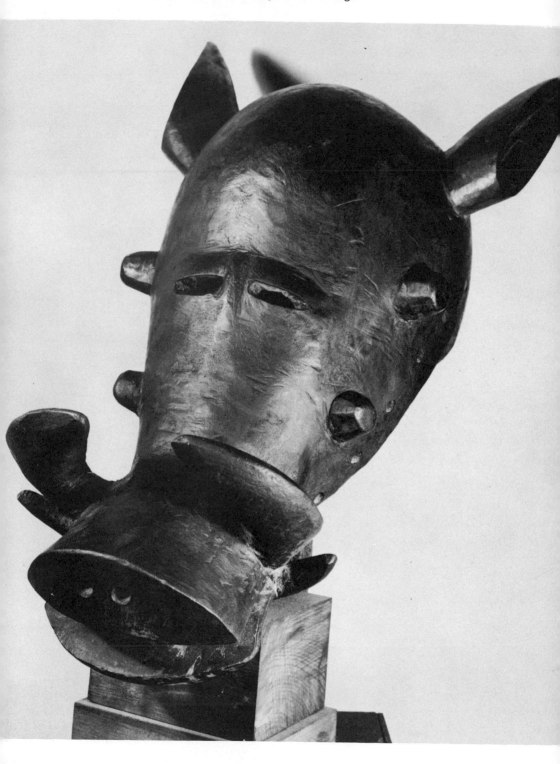

44. Statue. Alangua, Ivory Coast. 9½" high.

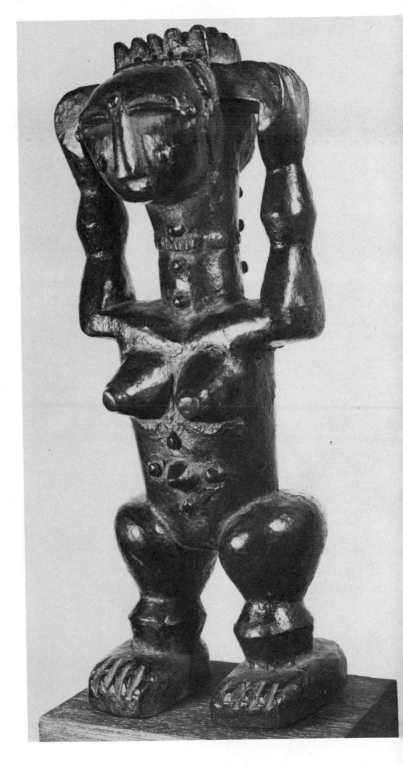

GHANA

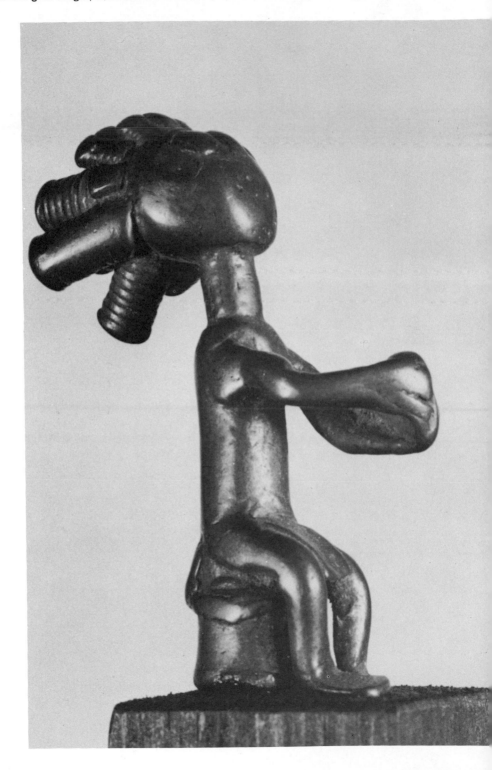

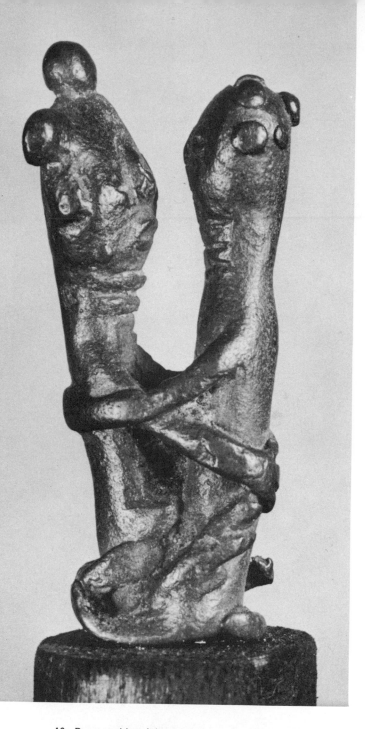

46. Brass gold weight, joined couple. Ashanti, Ghana (Gold Coast). 2″ high.

47. Fertility figure, Akua Mma or Akua Ba. Ashanti, Ghana (Gold Coast). 11″ high.

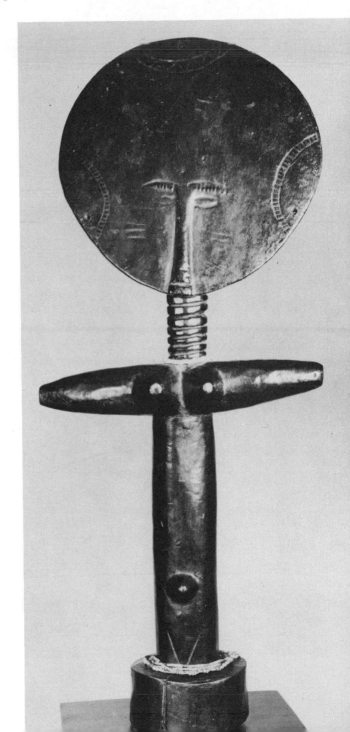

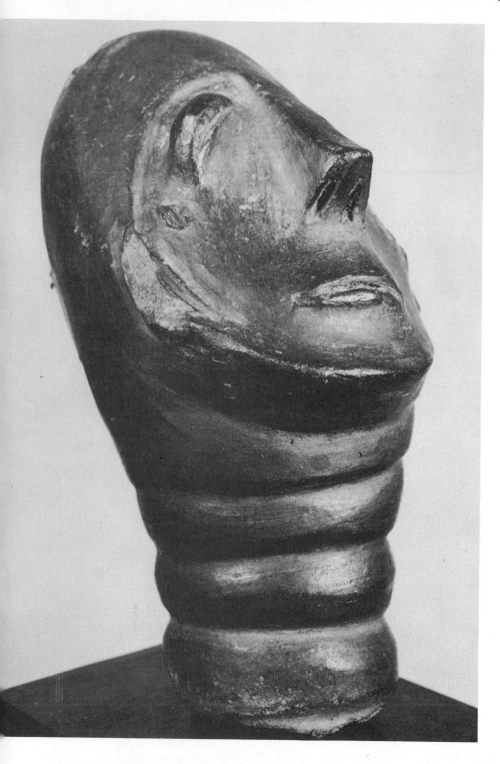

BRITISH
NIGERIA

49. Statue protecting the twins, Ibeji. Yoruba, Br. Nigeria. 10¼" high.

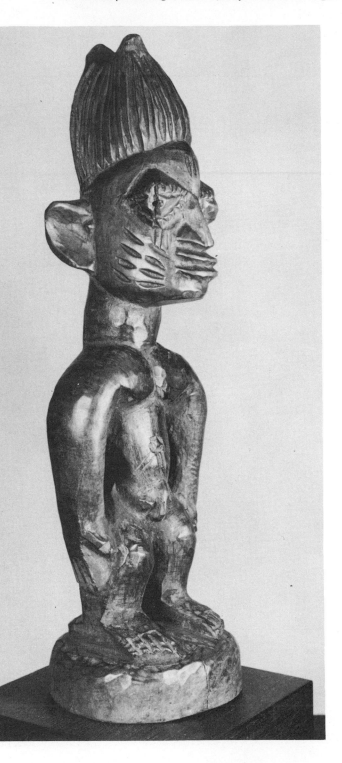

50. Gelede society mask. Yoruba, Br. Nigeria. 11″ high.

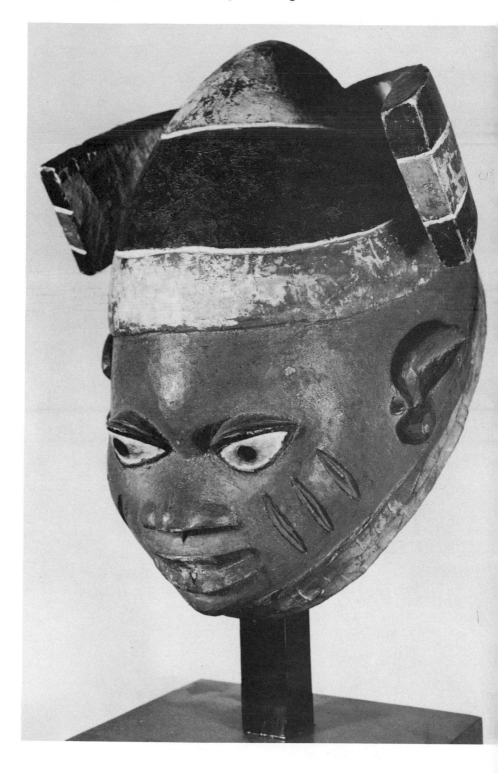

51. Equestrian figure, representing Shango, God of lightning. Yoruba, Br. Nigeria. 3″ high.

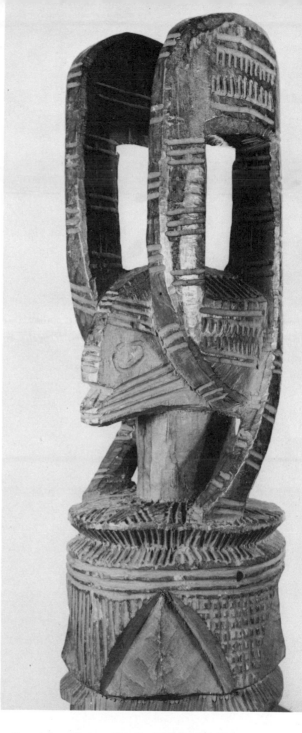

52. Household protective statue, Ikenga. Ibo, Br. Nigeria. 19″ high.

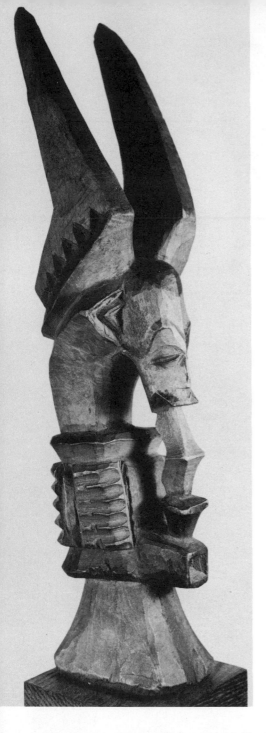

53. Household protective statue with pipe, Ikenga. Ibo,
 Br. Nigeria. 13¼″ high.

54. Sitting figure. Ibo, Br. Nigeria. 10″ high.

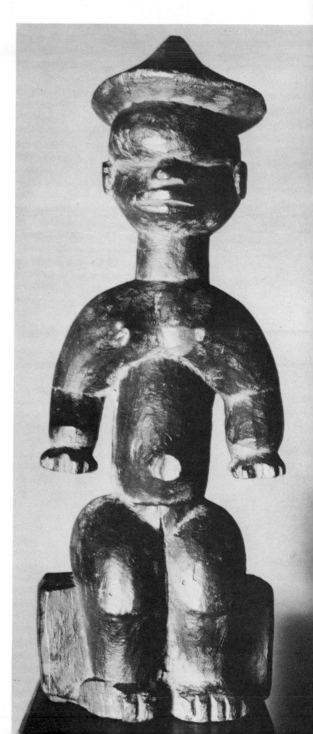

55. Burial mask, Mmo society. Ibo (Onitsha province). Br. Nigeria. 14½" high.

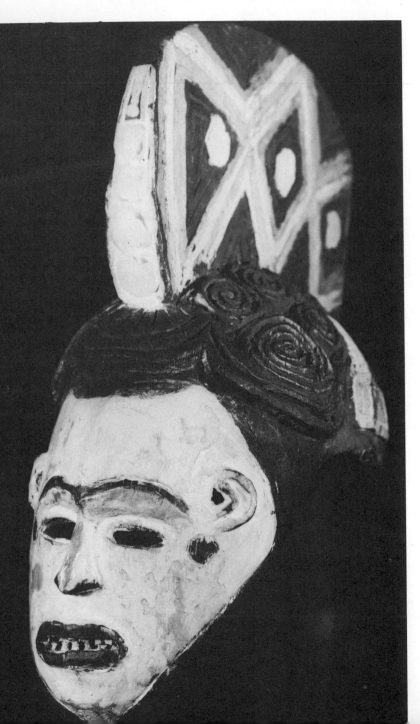

56. Burial mask, Mmo society. Ibo (Onitsha province). Br. Nigeria. 9″ high.

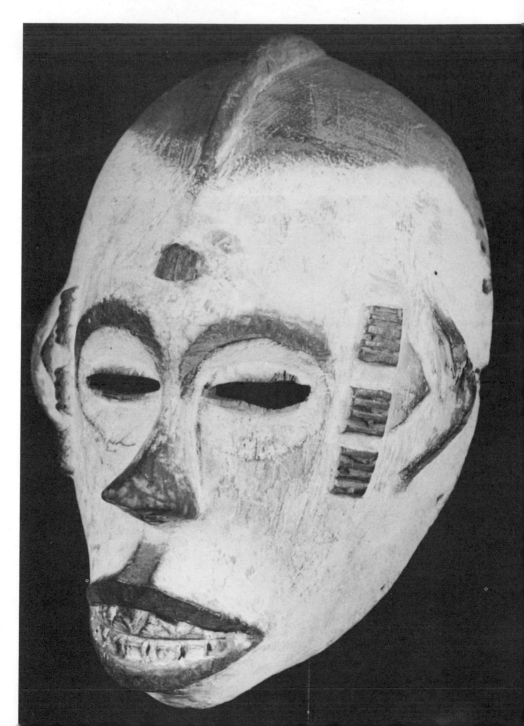

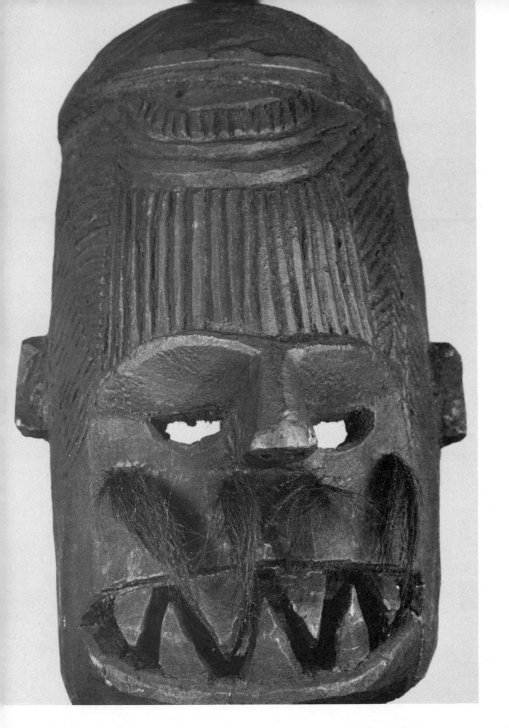

57. Ekpo society mask. Ibibio (also Ibo), Br. Nigeria. 12″ high.

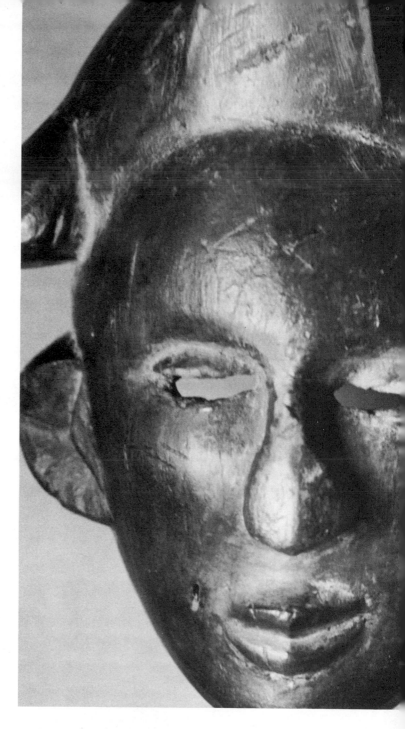

58. Mask, Western Ibibio (Anang), Br. Nigeria. 8½″ high.

59. Bronze plaque, representing a warrior. Bini (Benin Kingdom), Br. Nigeria. 15″ high.

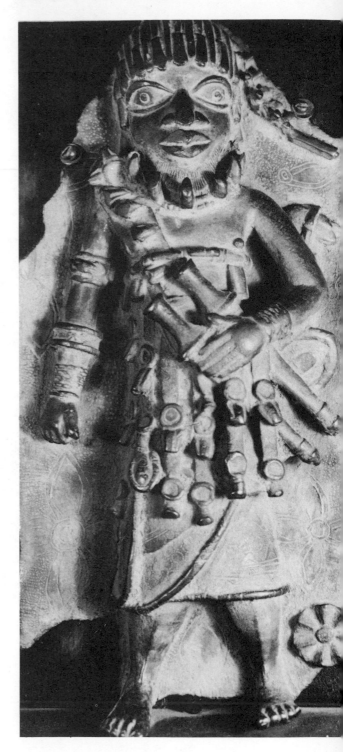

60. Section of a six feet long fully carved ivory tusk. The figure represents the
 Oba (king) with cat-fish legs. Detail: 8½″ high.

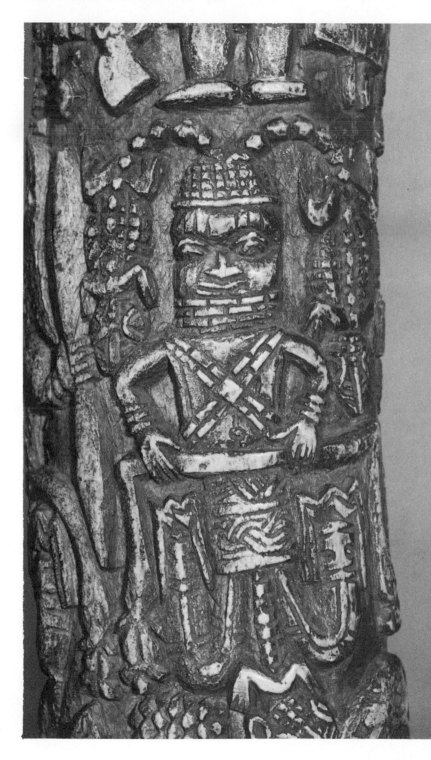

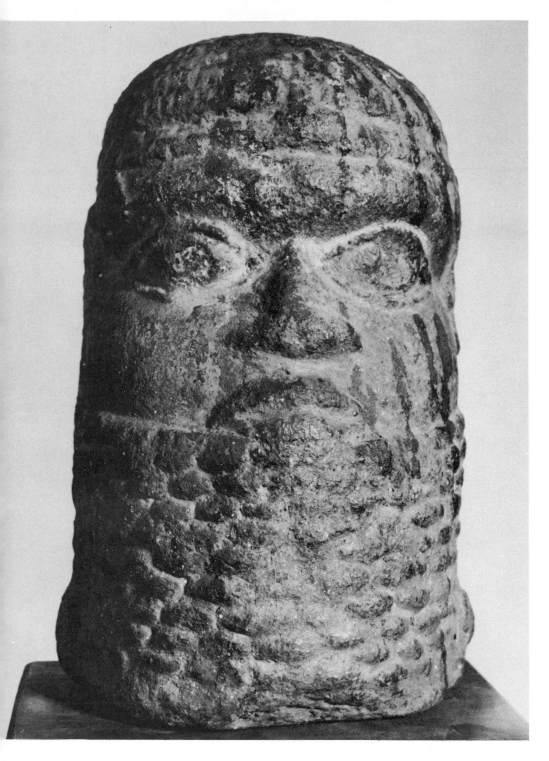

61. Terra-Cotta head. Bini (Benin Kingdom). 7″ high.

62. Head of a bronze musical instrument, representing an
Ibis bird. Detail: 5″ high.

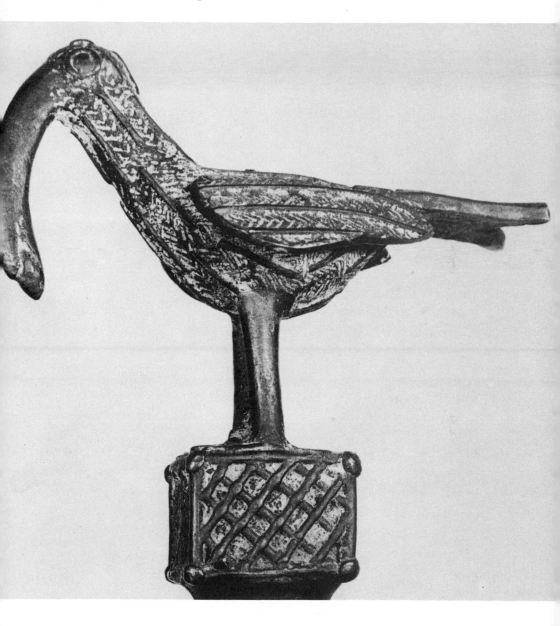

CAMEROONS

63. Mask. Probably Anyang, Cameroons. 12″ high.

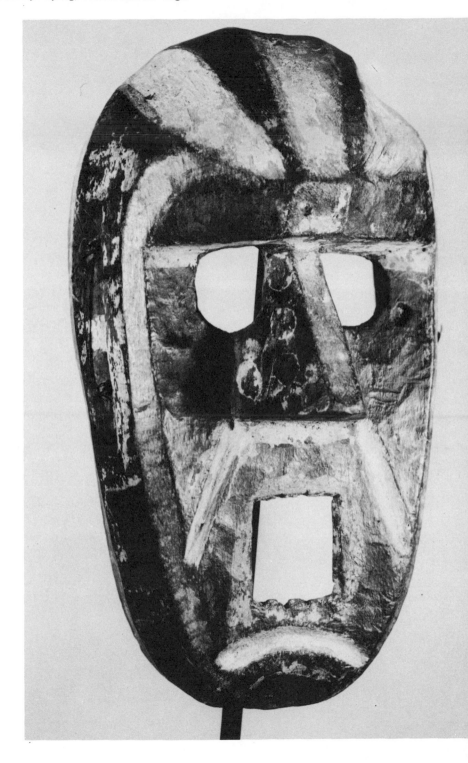

64. Skin covered wooden head. Ekoi, Cameroons. 13″ high.

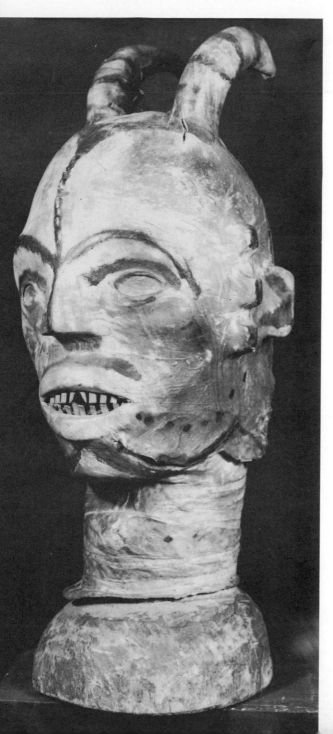

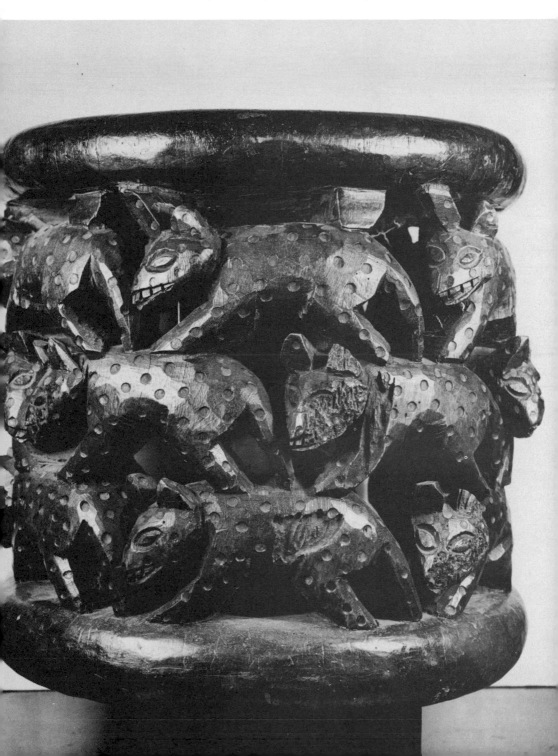

65. Carved stool. Bamum, Grassland, Cameroons. 13″ high, 12¼″ diam.

66. Head of an ivory horn. Bafo, Cameroons. Detail: 4½″ high.

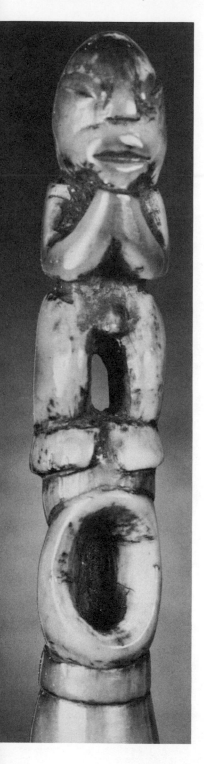

FRENCH
EQUATORIAL
AFRICA

68. Mask. Ogowe River region, Gabun, F.E.A. 15″ high.

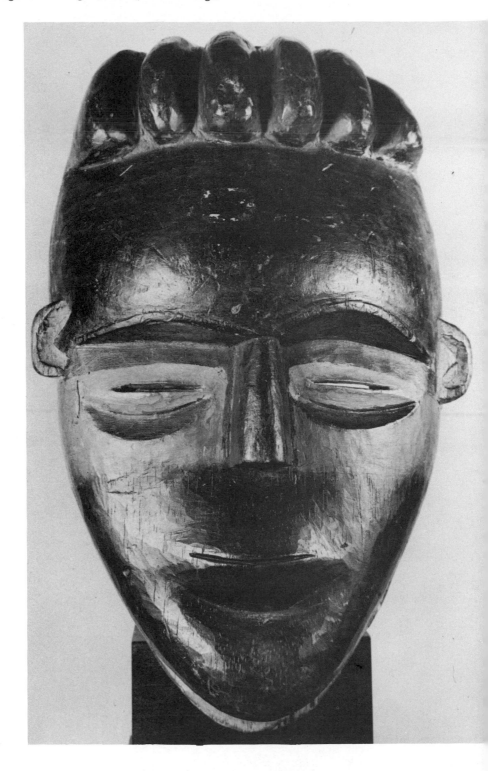

69. Mask. M'Pongwe, Gabun, F.E.A. 11½″ high.

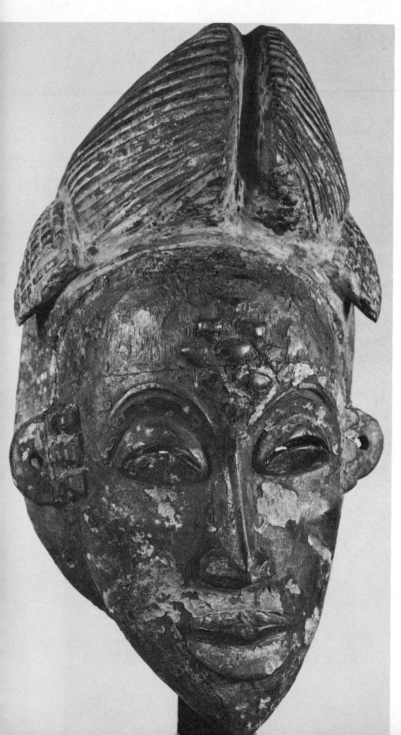

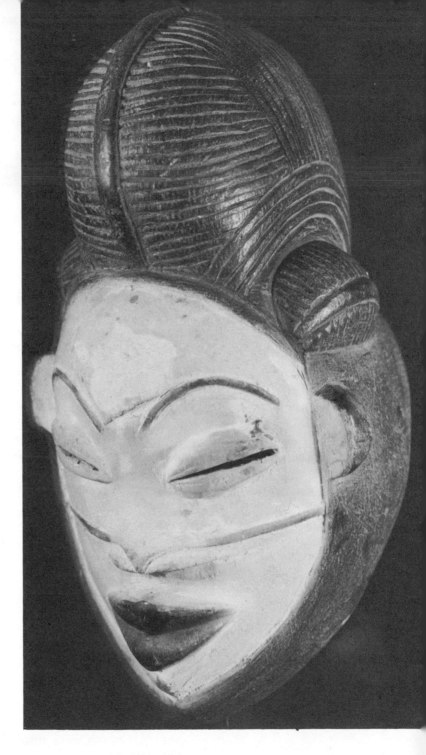

70. Mask. M'Pongwe, Gabun, F.E.A. 11½" high.

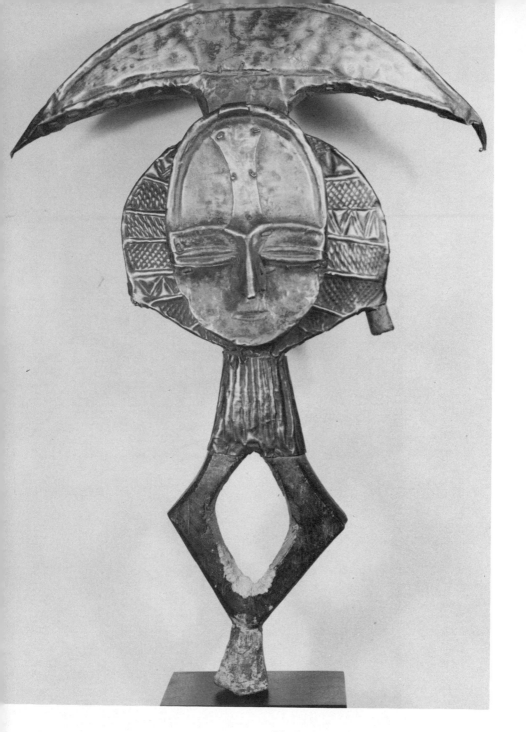

71. Funerary figure. Bakota, Gabun, F.E.A. 18″ high.

72. Head of a funerary figure. Bakota, Gabun, F.E.A. Detail: 9″ high.

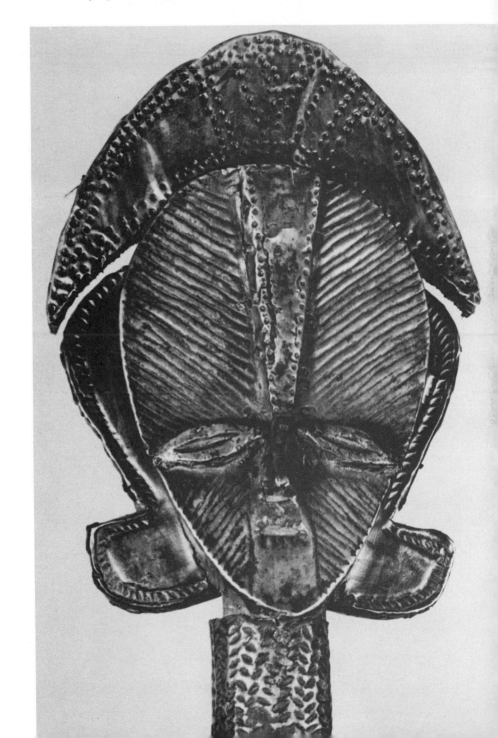

73. Bieri figure. Pangwe, Gabun, F.E.A. 16″ high.

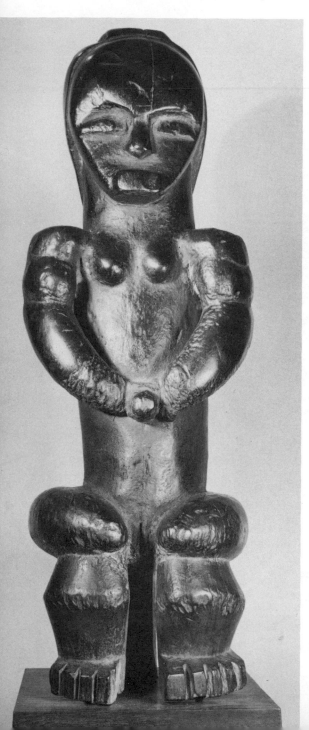

74. Detail of previous figure. 9½″ high.

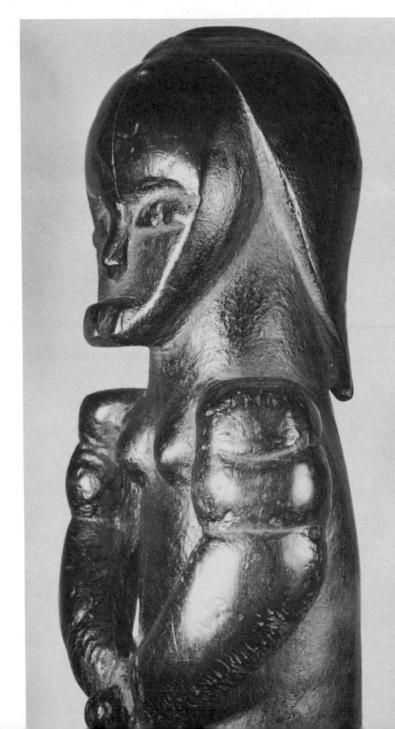

75. Household protective statue. Babembe, Middle Congo, F.E.A. 7″ high.

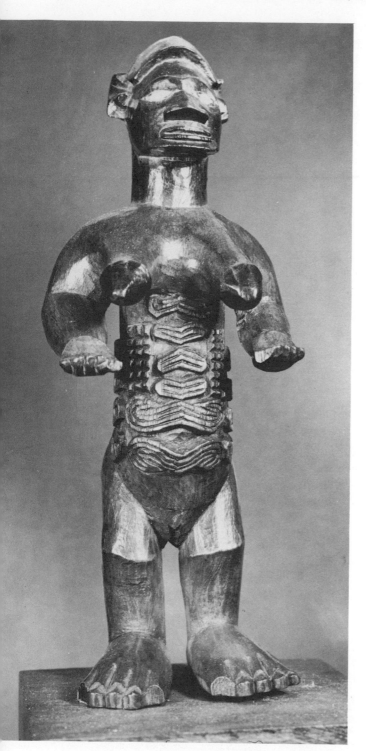

76. Head-dress. Kuyu, Middle Congo, F.E.A. 17″ high.

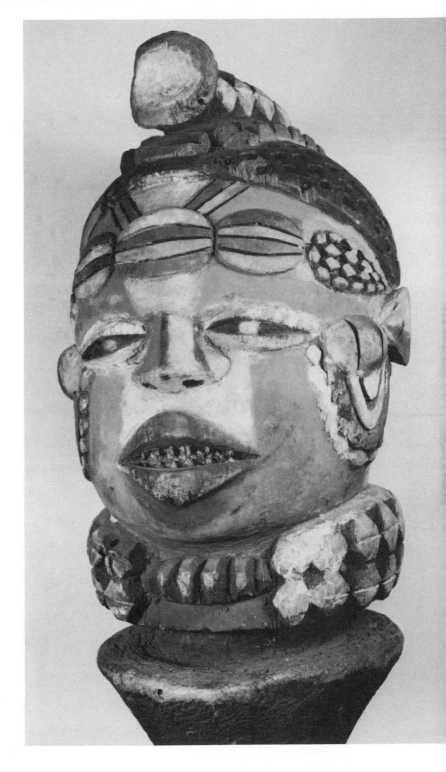

BELGIAN CONGO

77. Statue. Azande, Belgian Congo. 10½″ high.

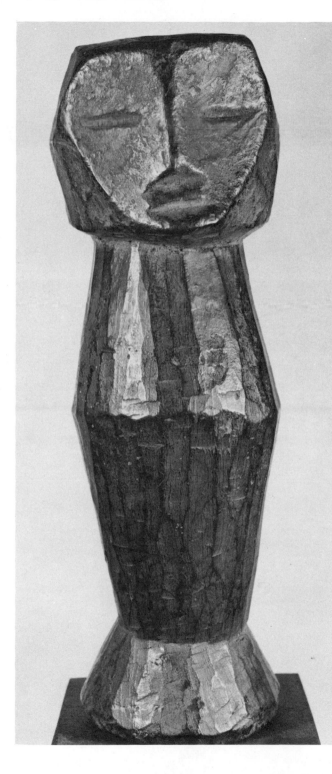

78. Mask. Probably Azande, Belgian Congo. 11″ high.

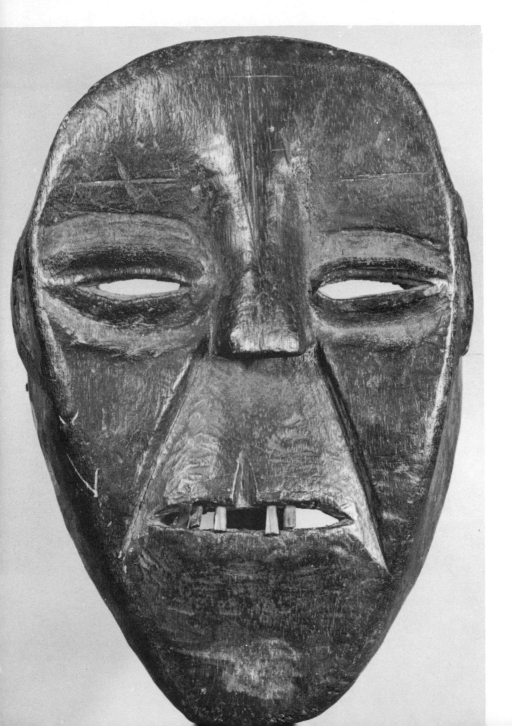

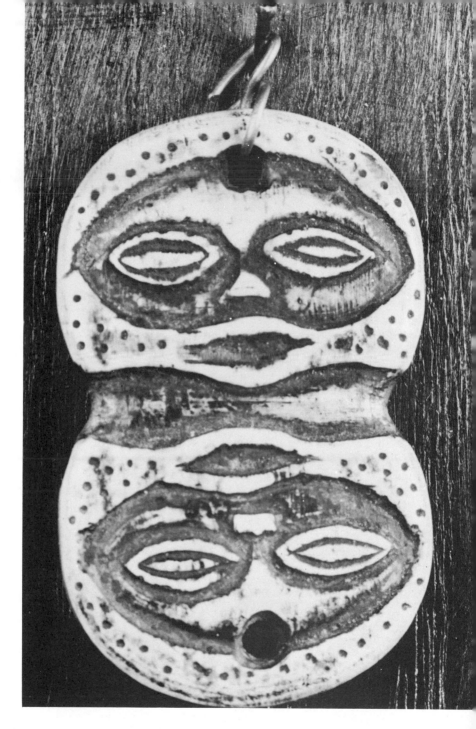

79. Ivory pendant. Bahuana, Belgian Congo. 2½" high.

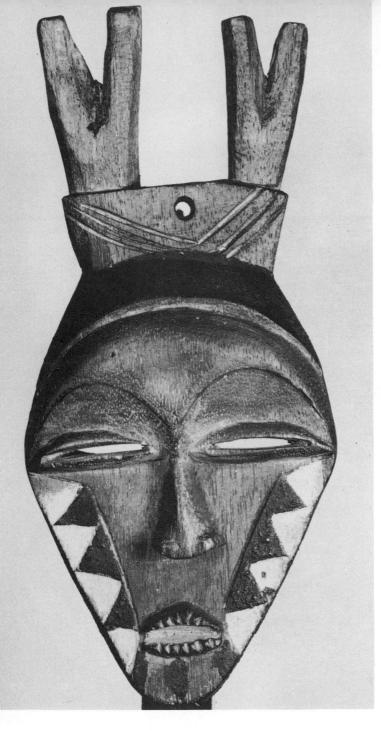

80. Mask. Bakete, Belgian Congo. 11″ high.

81. Magical statue with magical substance. Bakongo, Belgian Congo. 8½″ high.

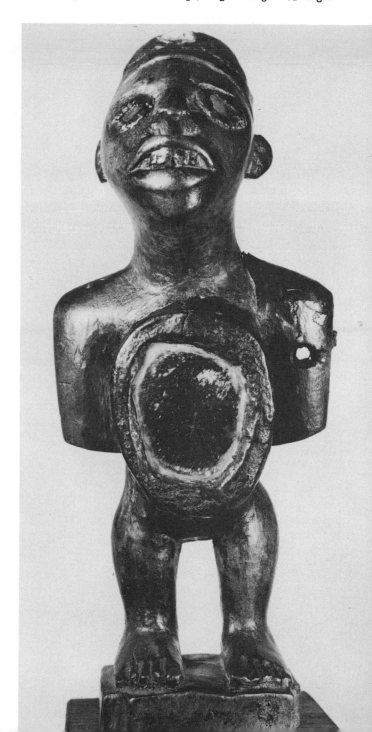

82. Magical statue, with raised hand and magical substance.

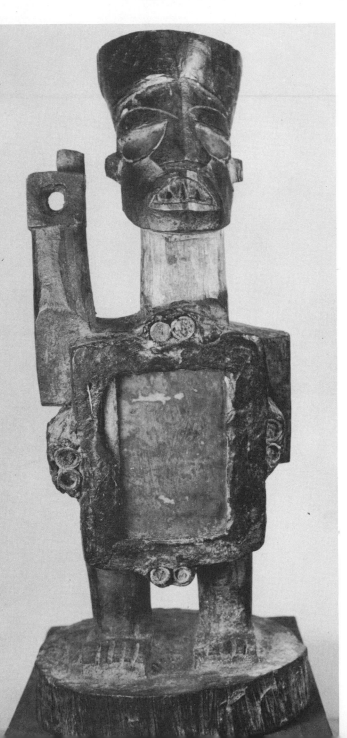

83. Kneeling magical statue, with magical substance.
 Bakongo, Belgian Congo. 9½″ high.

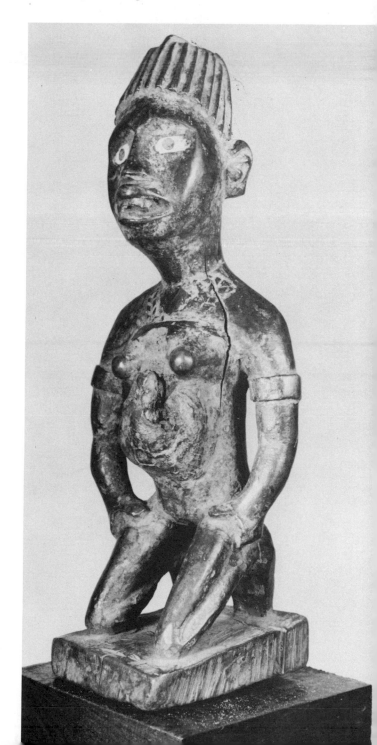

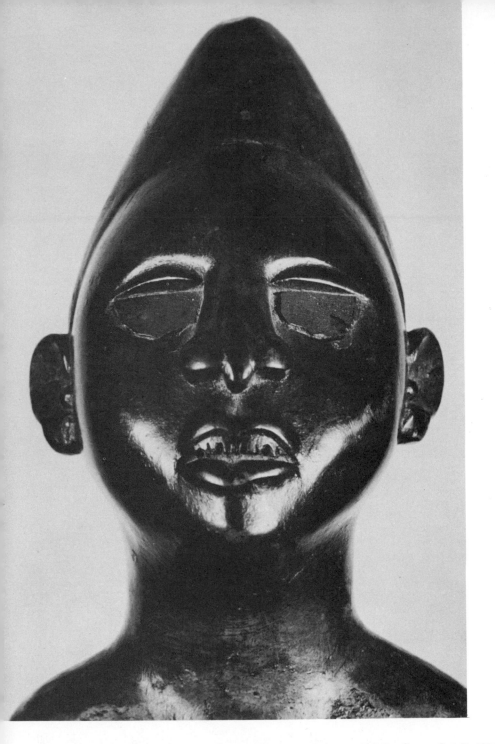

84. Head of a magical statue. Bakongo, Belgian Congo. Detail: 4½″ high.

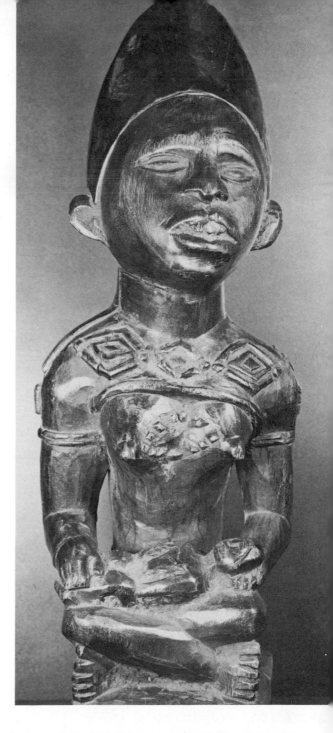

85. Seated female figure with child. Bakongo, Belgian Congo. 14½″ high.

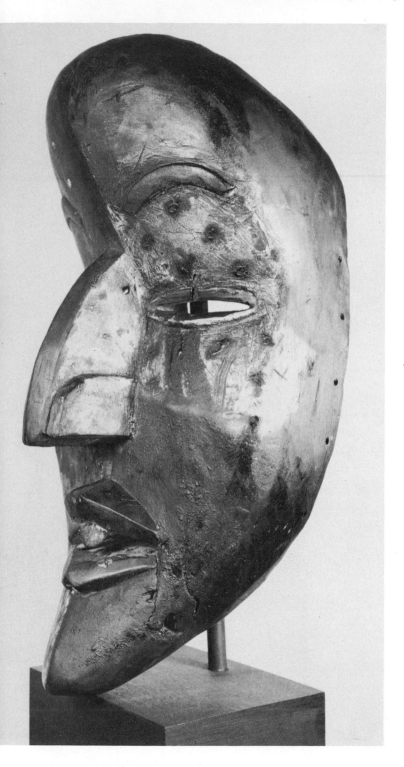

87. Powder container. Bakongo, Belgian Congo. 4″ high.

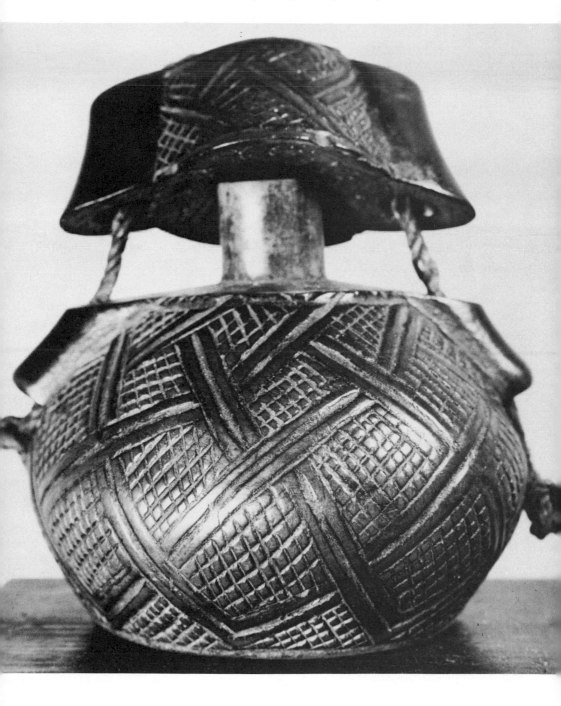

88. Figure, created under influence of Christian saint figures. Bakongo (with Bateke influence). 19½″ high.

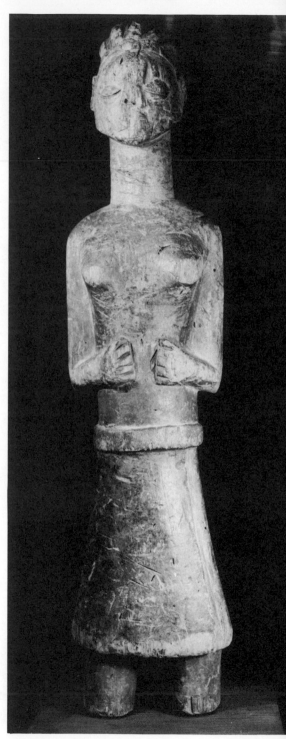

89. Head of a staff. Bakuba, Belgian Congo. 4″ high.

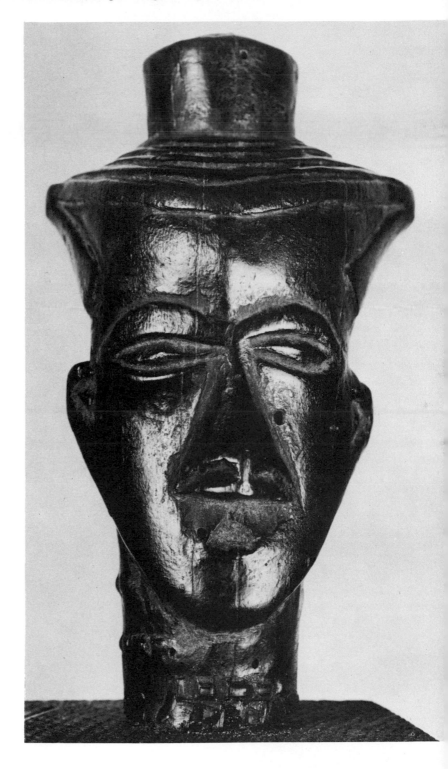

90. Head of a wooden bell. Bakuba, Belgian Congo. Detail: 4½″ high.

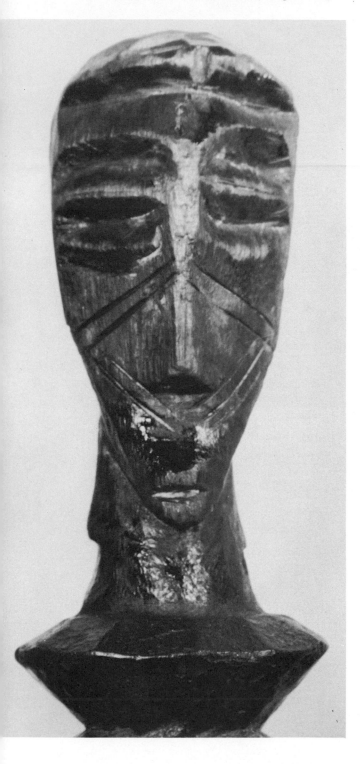

91. Mortar. Bakuba, Belgian Congo. 5½″ high.

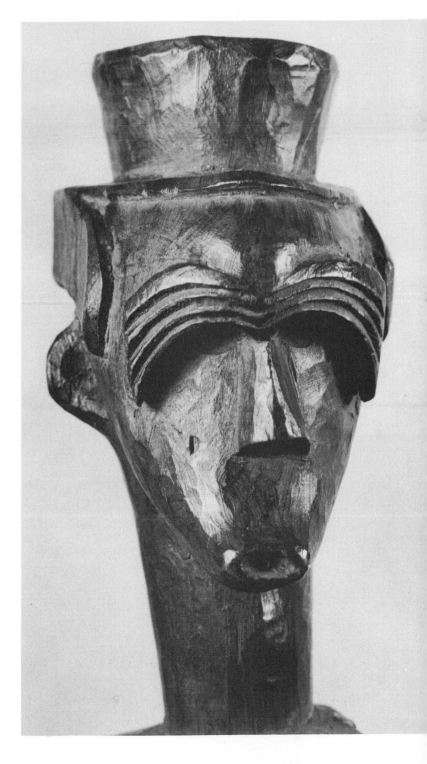

92. Mask. Probably Bakuba, Belgian Congo. 14″ high.

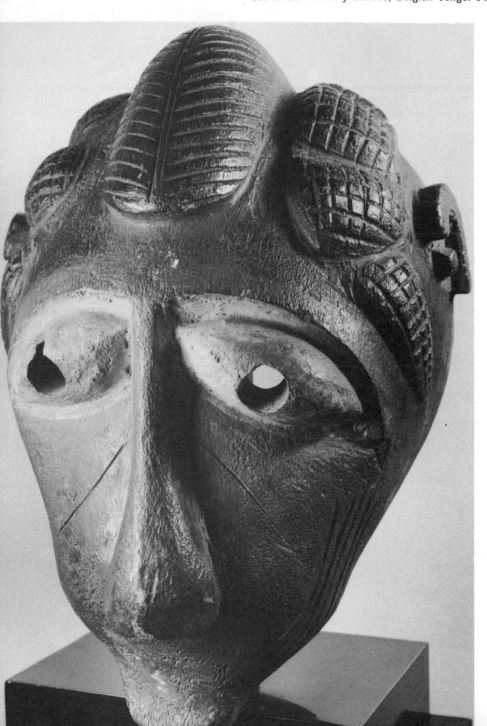

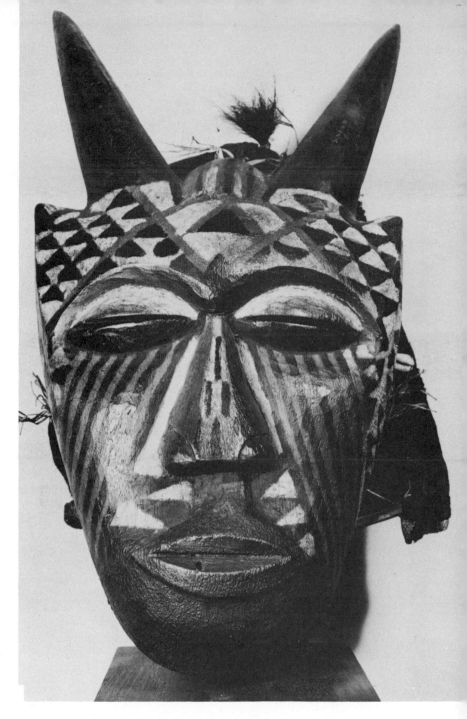

93. Mask, polychromed. Bakuba, Belgian Congo. 17" high.

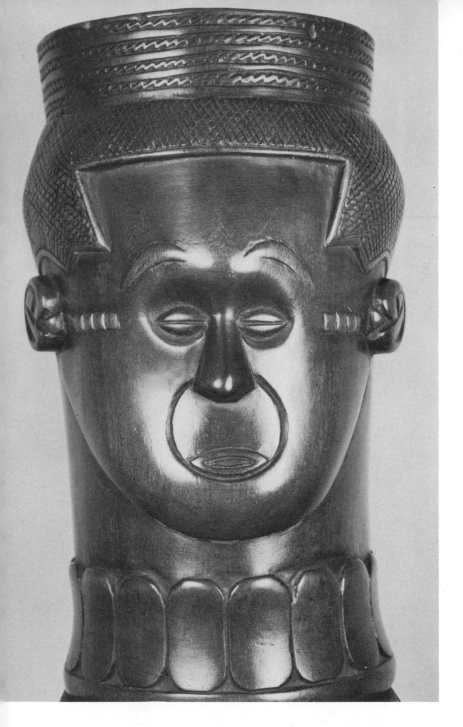

94. Ceremonial Cup. (Head), Bakuba, Belgian Congo. 8″ high.

95. Ceremonial Cup. (Head, on one foot, with handle.)
 Bakuba, Belgian Congo. 9″ high.

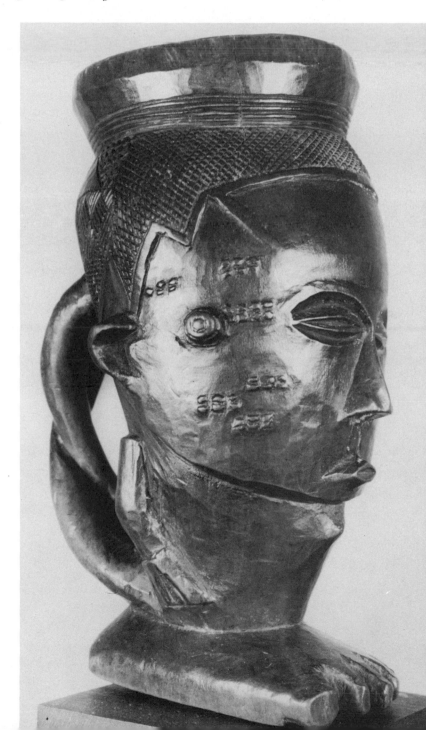

96. Ceremonial Cup. (Handle with human face and hand.)
Bakuba, Belgian Congo. 7½″ high.

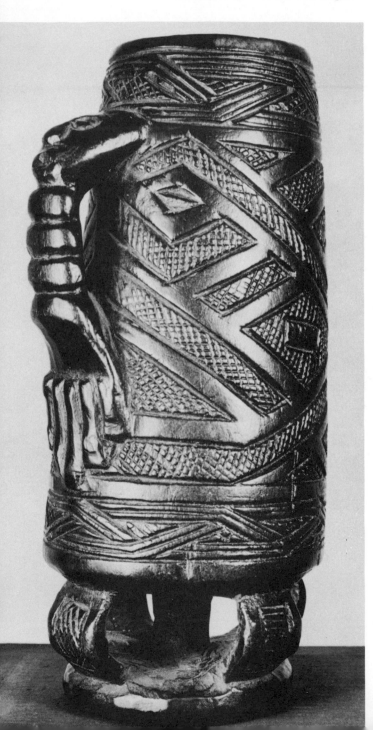

97. Statue. Baluba, Belgian Congo. 13″ high.

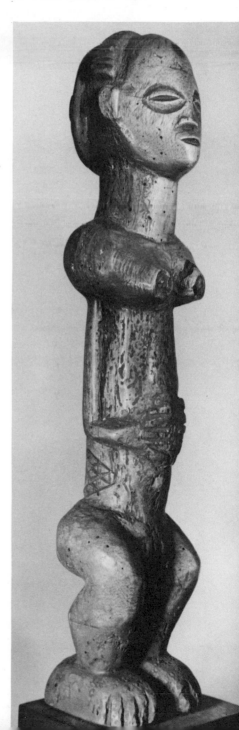

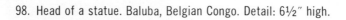
98. Head of a statue. Baluba, Belgian Congo. Detail: 6½″ high.

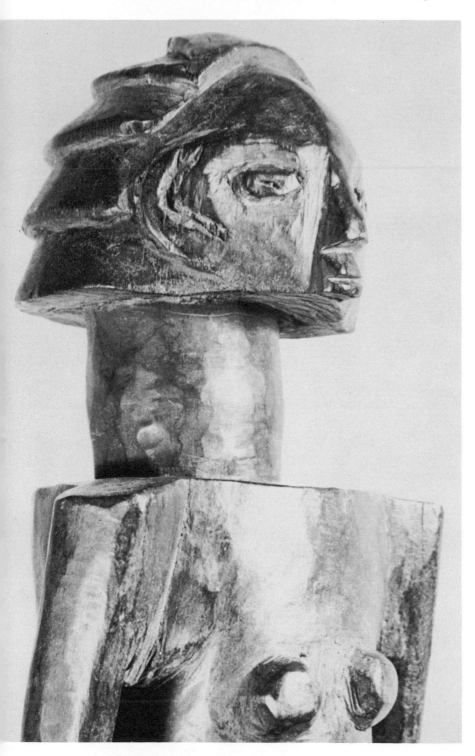

99. Head of a statue. Baluba, Belgian Congo. Detail: 3½″ high.

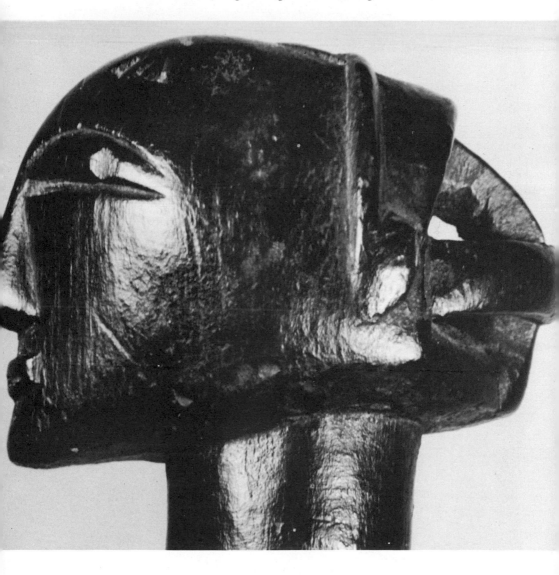

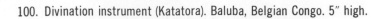
100. Divination instrument (Katatora). Baluba, Belgian Congo. 5″ high.

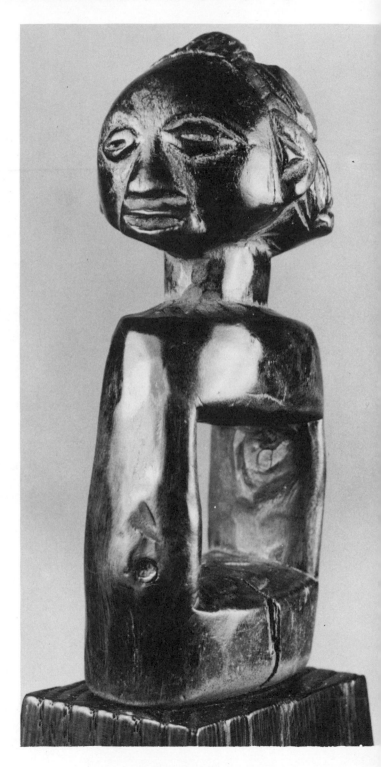

101. Ivory amulet. Baluba, Belgian Congo. 3½″ high.

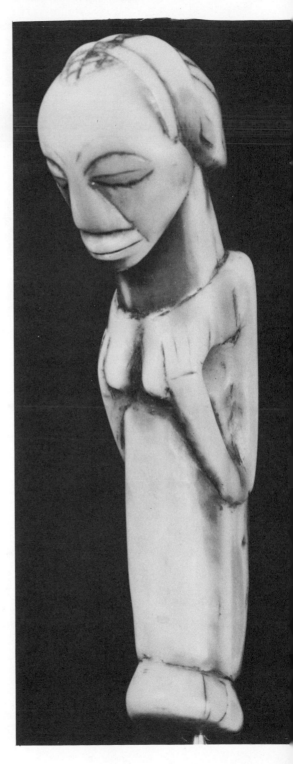

102. Ivory statue. Baluba, Belgian Congo. 3½" high.

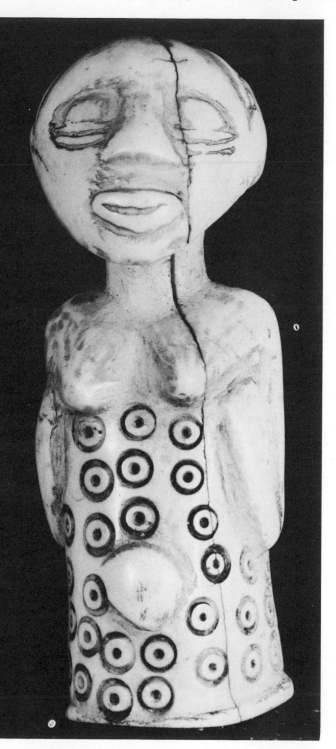

103. Stool with double figure (male and female). Baluba, Belgian Congo. 13½" high.

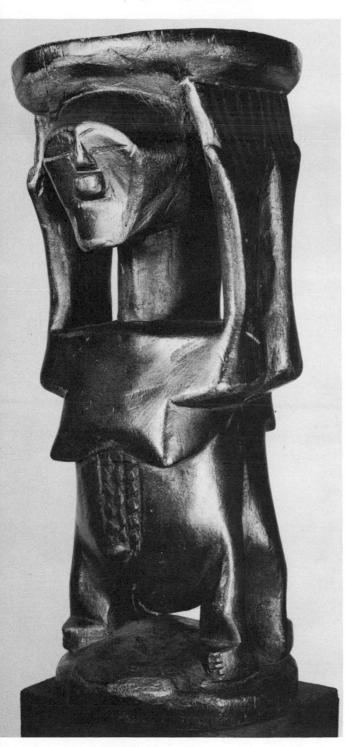

104. Stool with four figures. Baluba, Belgian Congo.
16″ high, 14″ in diameter.

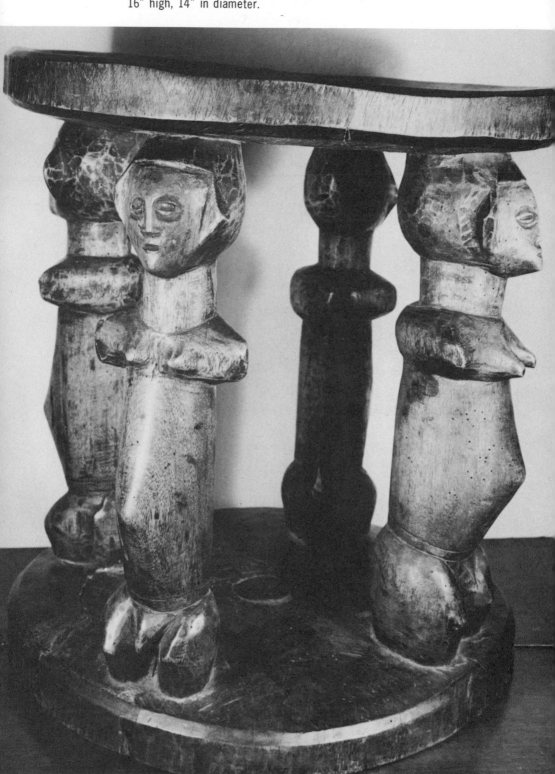

105. Head-rest with two figures. Baluba, Belgian Congo. 7″ high.

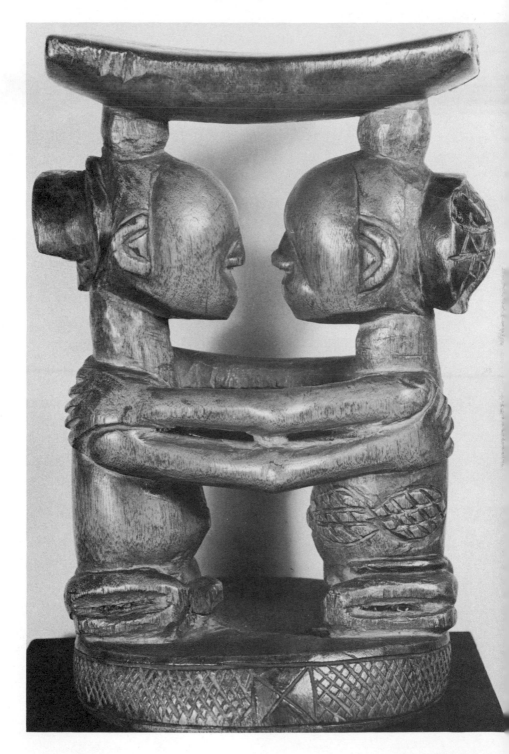

106. Mask (Kifwebe). Baluba, Belgian Congo. 14″ high.

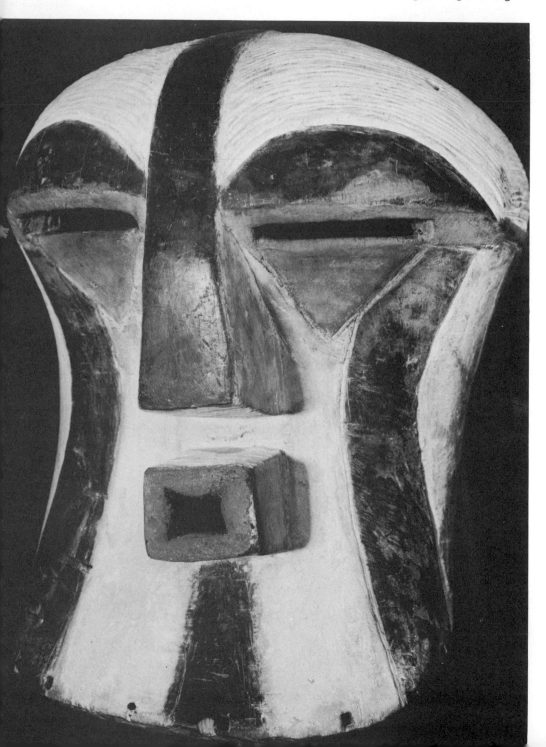

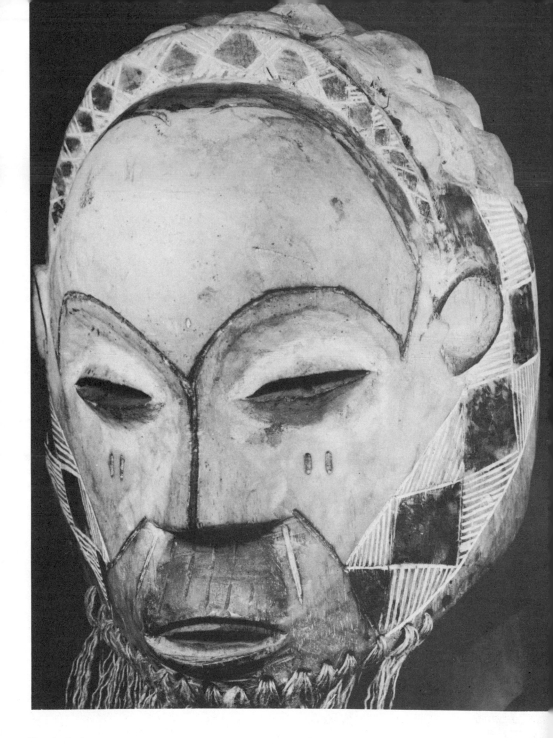

107. Mask. Baluba, Belgian Congo. 15″ high.

108. Head of a staff. Balunda, Belgian Congo, also Ovimbundu, N. Angola Detail: 5″ high.

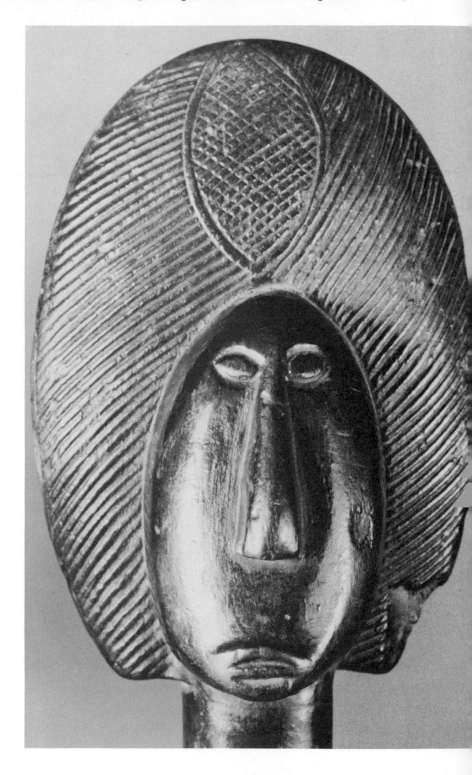

109. Head of a staff. Balunda, Belgian Congo. Detail: 3½" high.

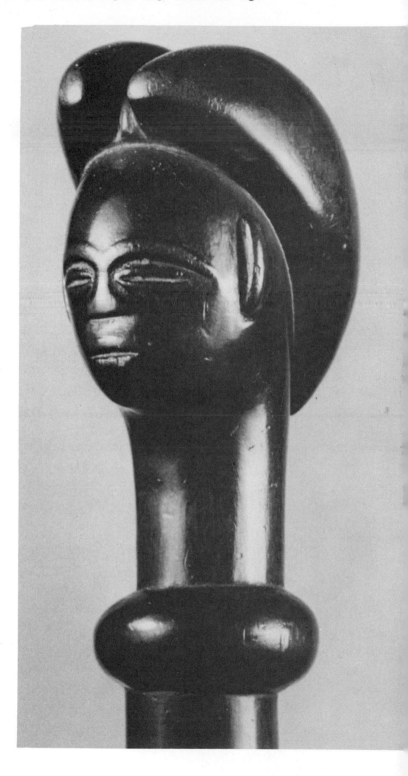

110. Statue, woman with a child. Balunda, Belgian Congo. Detail: 5″ high.

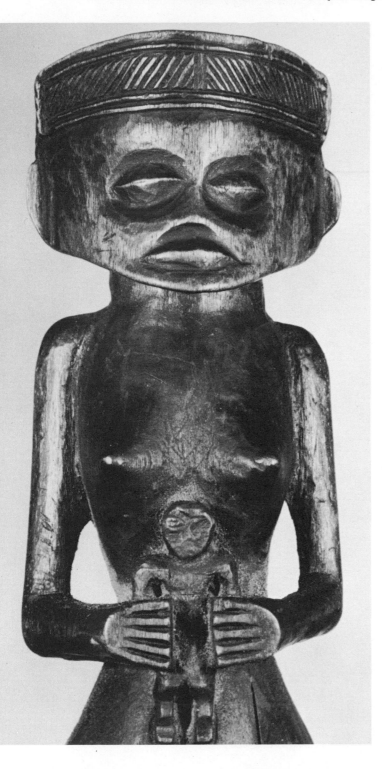

111. Statue. Bambala, Belgian Congo. 9″ high.

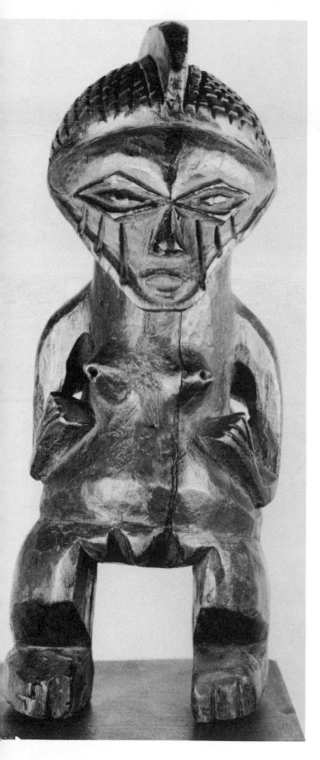

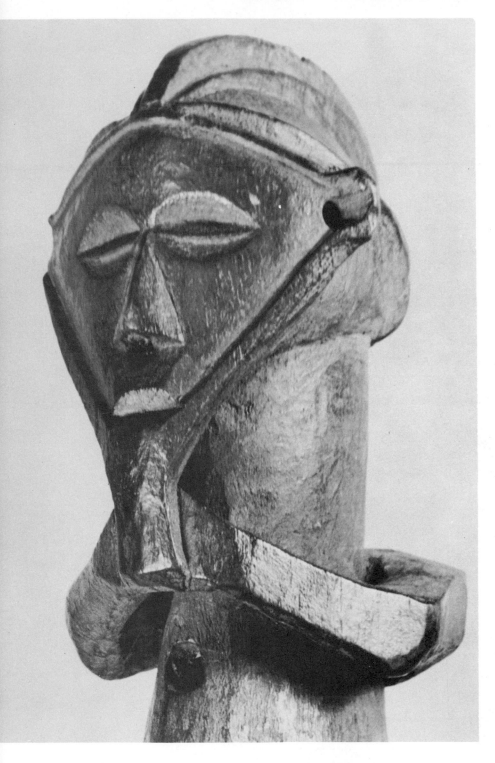

113. Statue (Lilwa). Bambole, Belgian Congo. 13″ high.

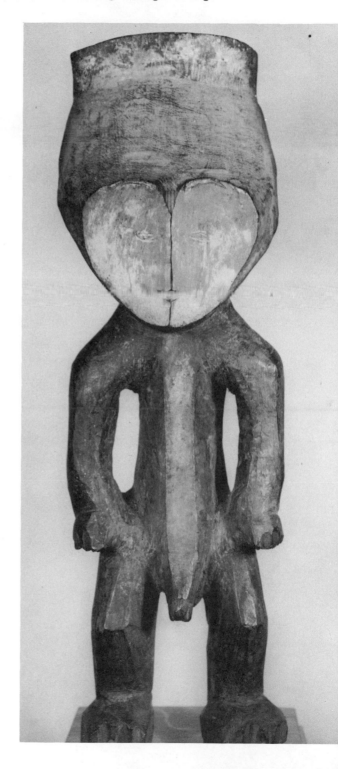

114. Statue. Bangala, Belgian Congo. 9″ high.

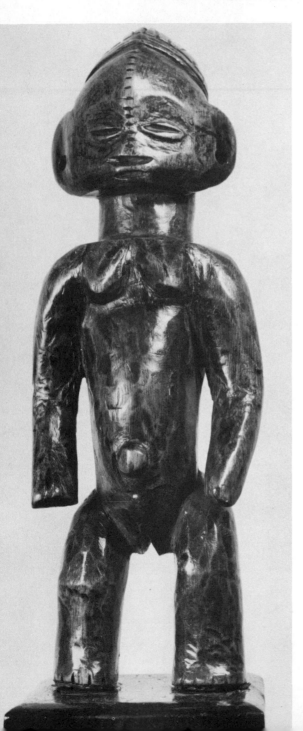

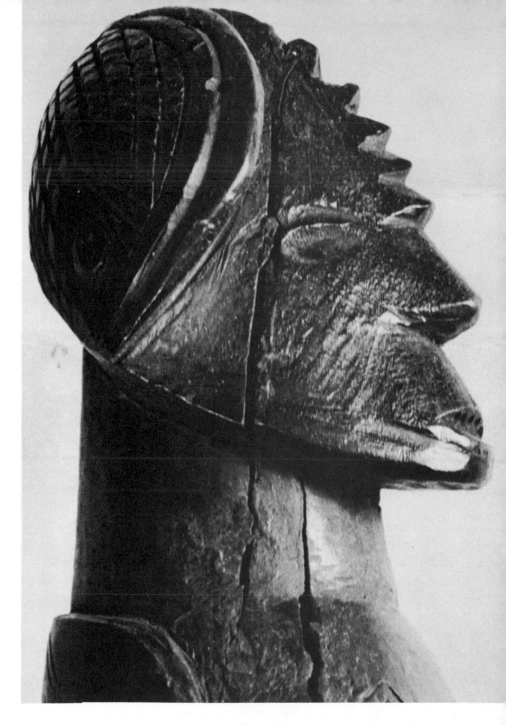

115. Head of a statue. Bangala, Belgian Congo. Detail: 5″ high.

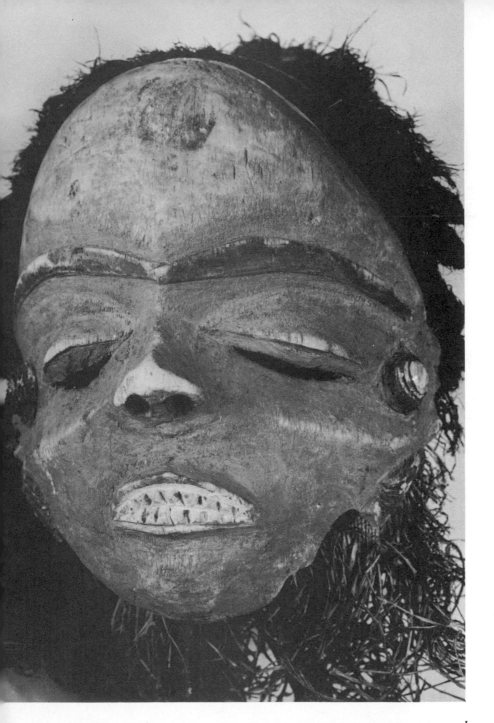

116. Mask, with raffia hair. Bapende, Belgian Congo. 8″ high.

117. Ivory mask, pendant. Bapende, Belgian Congo. 2″ high.

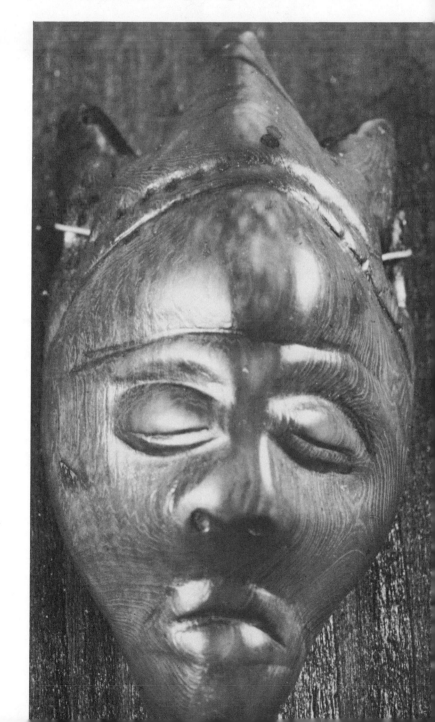

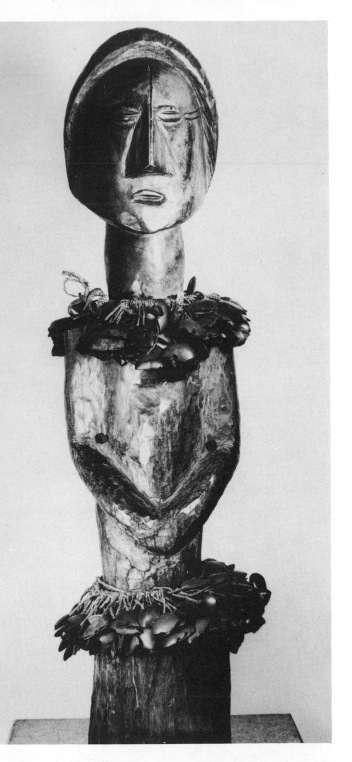

119. Magical statue with raffia skirt and snake skin necklace.
17″ high. Basonge, Belgian Congo.

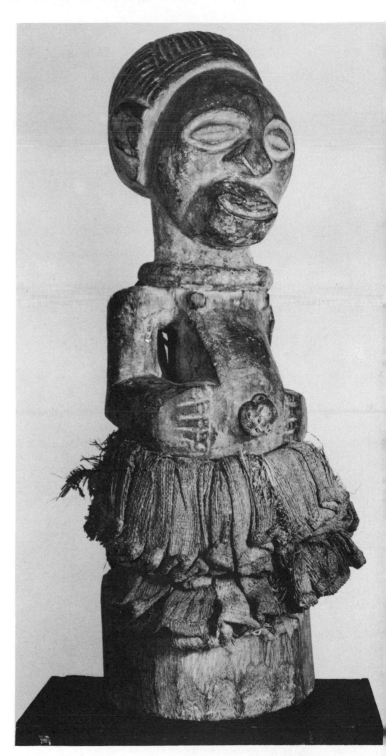

120. Statue. Basonge, Belgian Congo. 9½″ high.

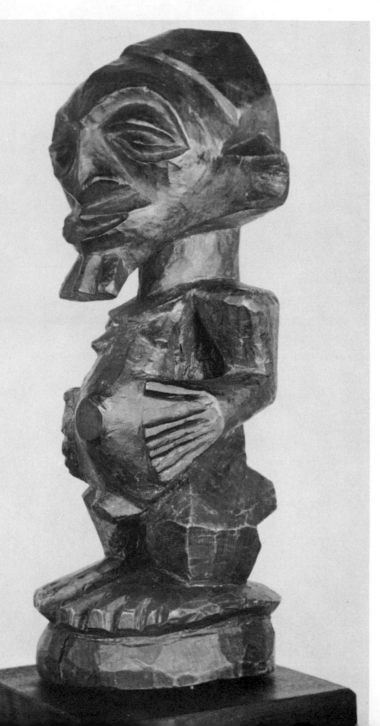

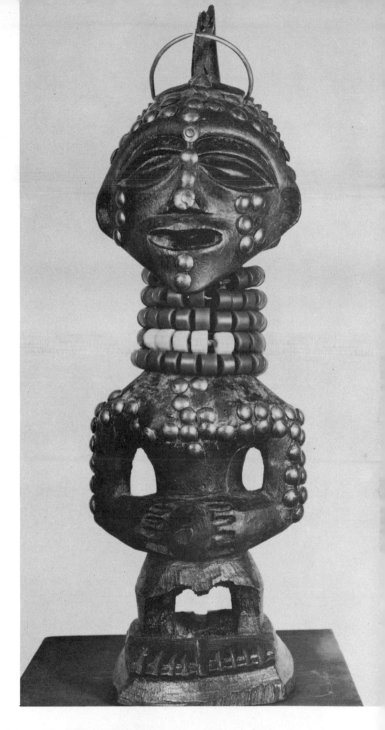

121. Magical statue with nails, bead necklace, horn and metal ring.
Basonge, Belgian Congo. 14″ high.

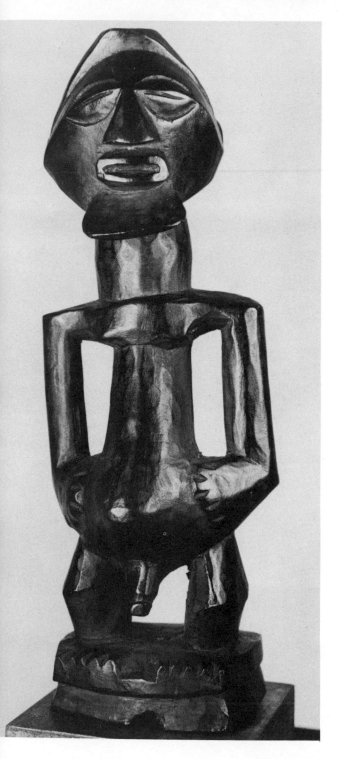

123. Head of a magical statue. Basonge, Belgian Congo. Detail: 3½″ high.

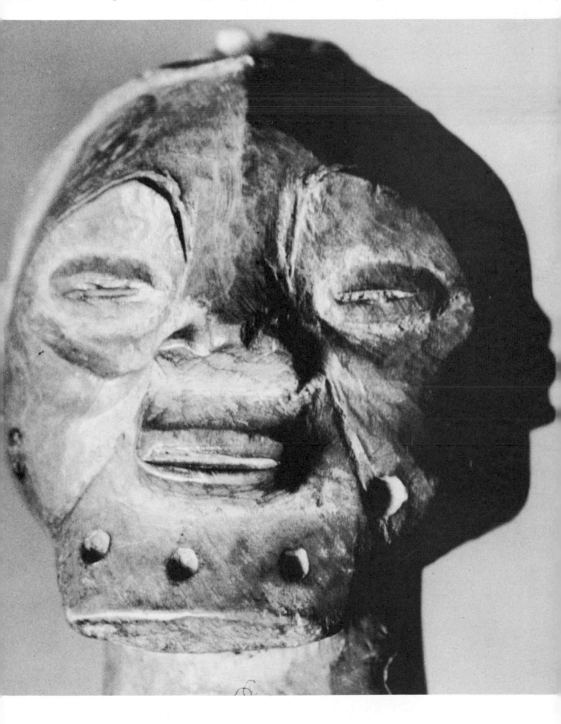

124. Ivory statue. Basonge, Belgian Congo. 3½" high.

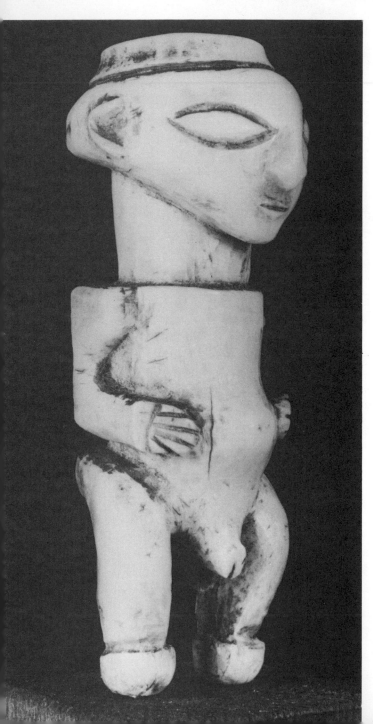

125. Ivory Whistle. Basonge, Belgian Congo. 3½" high.

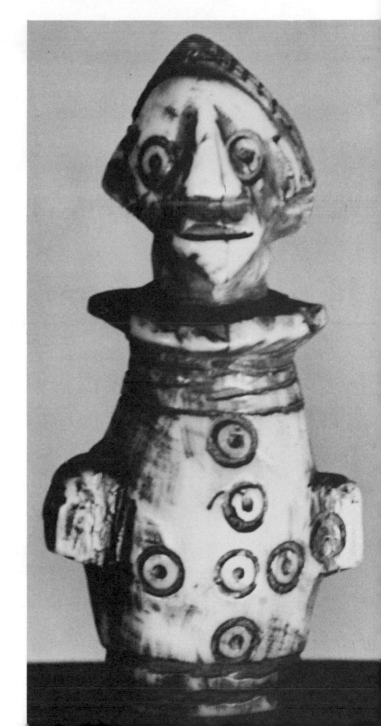

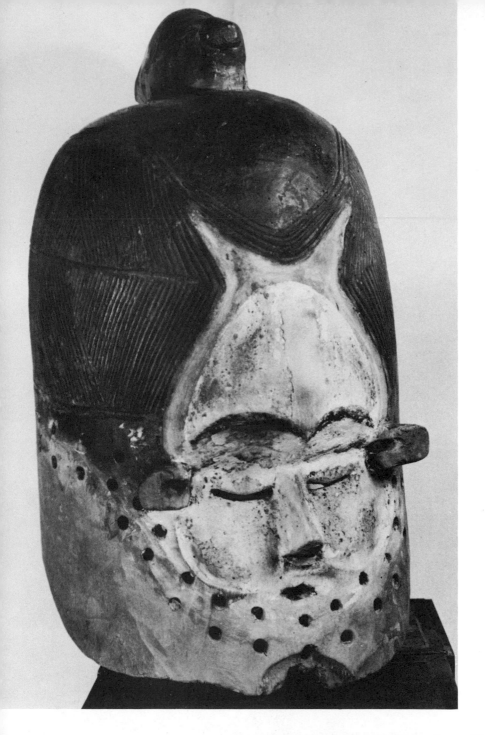

126. Hood mask. Basuku, Belgian Congo. 17″ high.

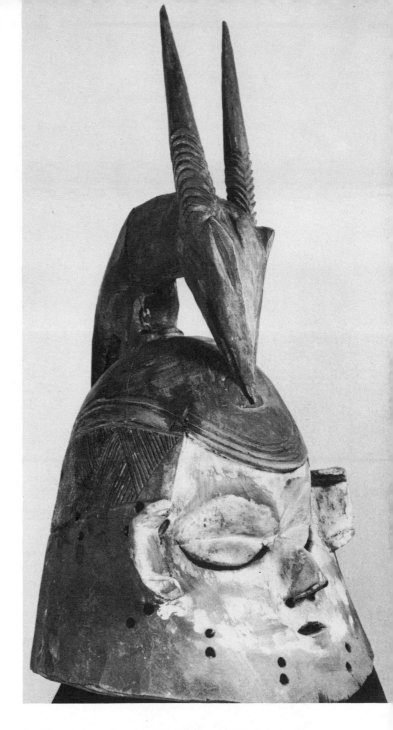

127. Hood mask with antelope. Basuku, Belgian Congo. 15″ high.

128. Statue. Batabwa, Belgian Congo. 18½" high.

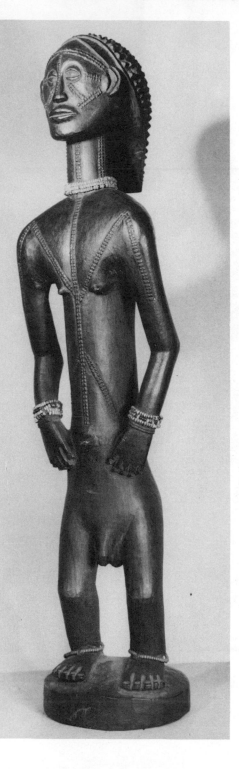

129. Detail of a statue. Batabwa, Belgian Congo. 5″ high.

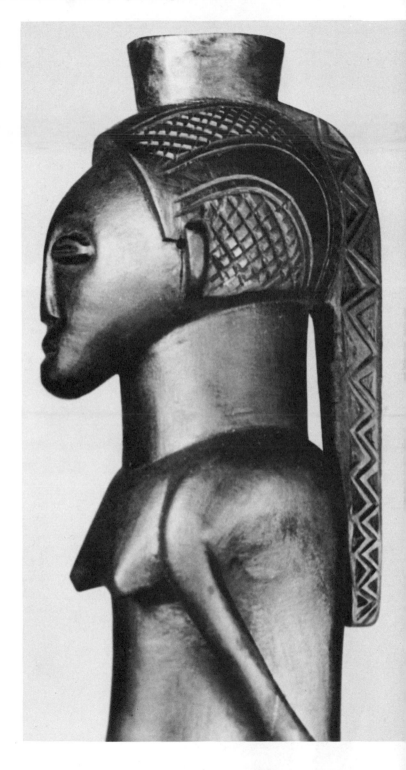

130. Magical statue with shirt-button for eyes. (Magical substance removed.) Bateke, Belgian Congo. 16″ high.

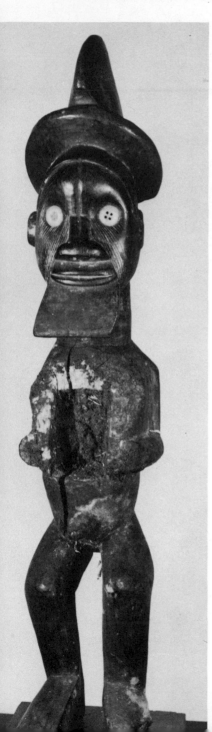

131A.

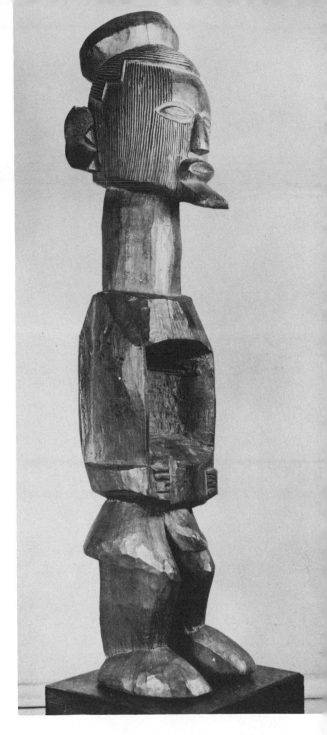

131. Magical statue. (Magical substance removed.)
Bateke, Belgian Congo. 15″ high.

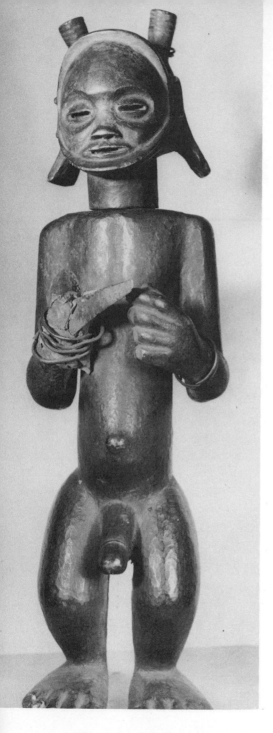

132. Statue. Batshioko, Belgian Congo. 14″ high.

133. Statue. Bayaka, Belgian Congo. 7″ high.

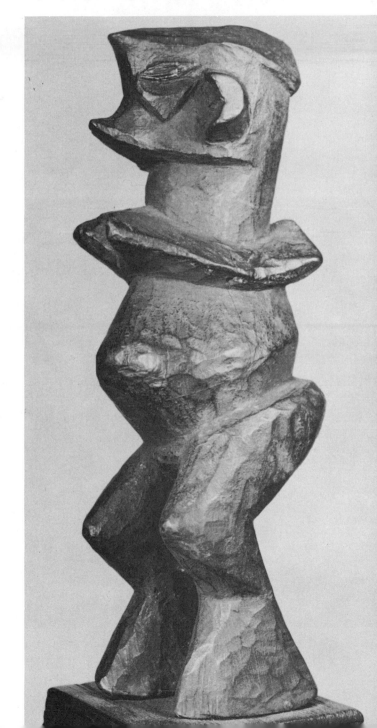

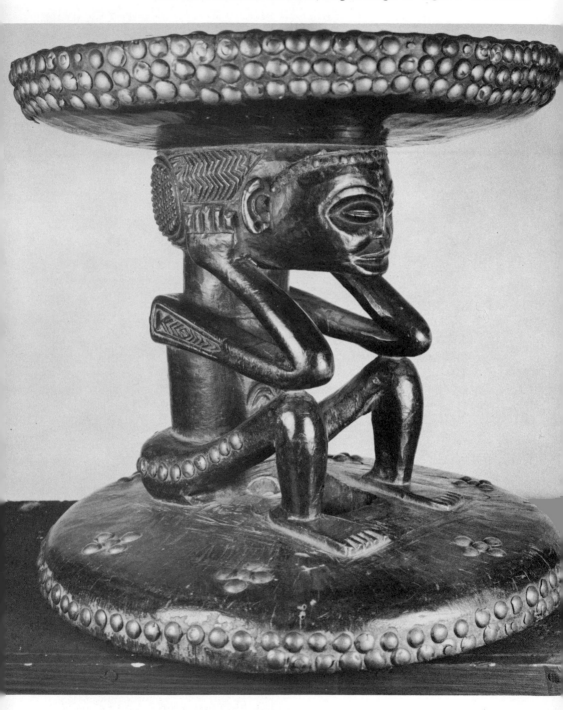

135. Comb. Batshioko, Belgian Congo. 8½″ high.

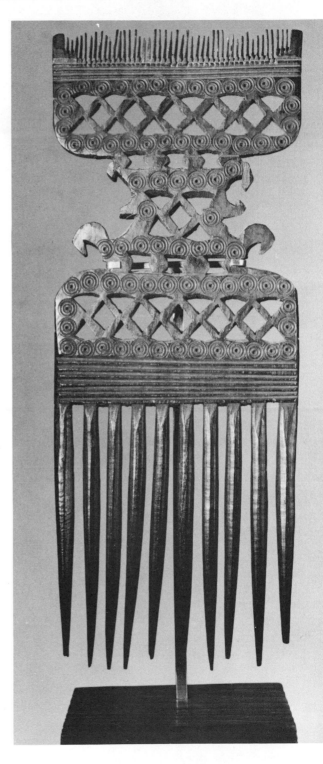

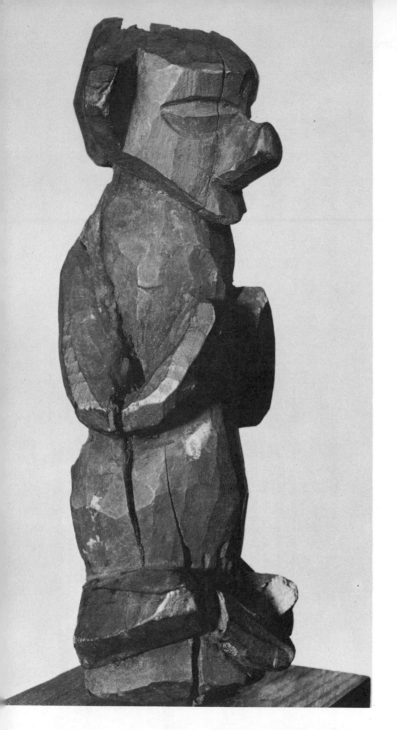

136. Statue. Bayaka, Belgian Congo. 9½" high.

137. Sitting figure. Bayaka, Belgian Congo. 6½" high.

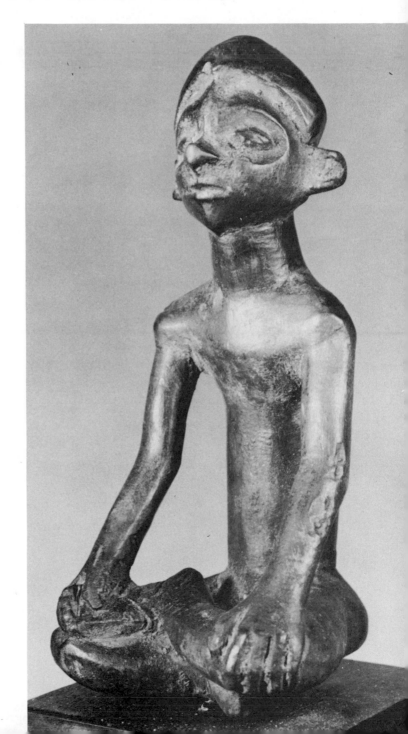

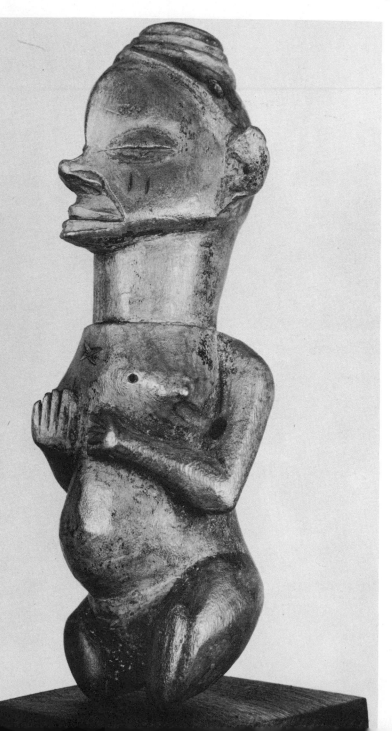

139. Statue. Bayaka, Belgian Congo. 15″ high.

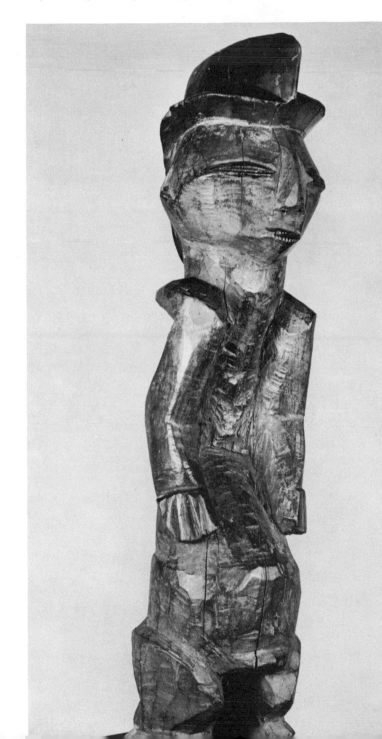

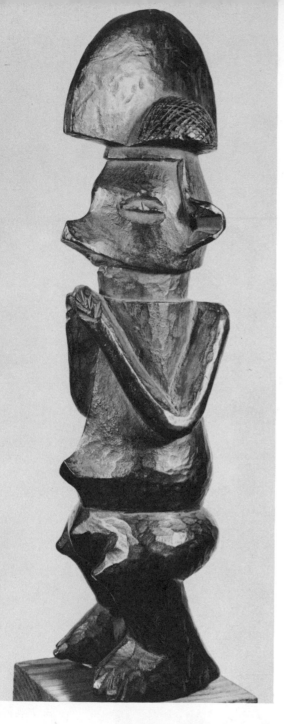

140. Statue. Bayaka, Belgian Congo. 11″ high.

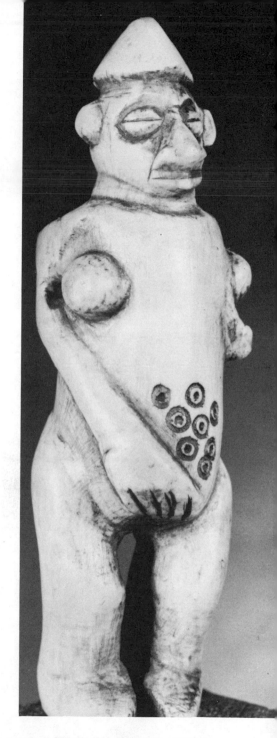

141. Ivory statue. Bayaka, Belgian Congo. 4″ high.

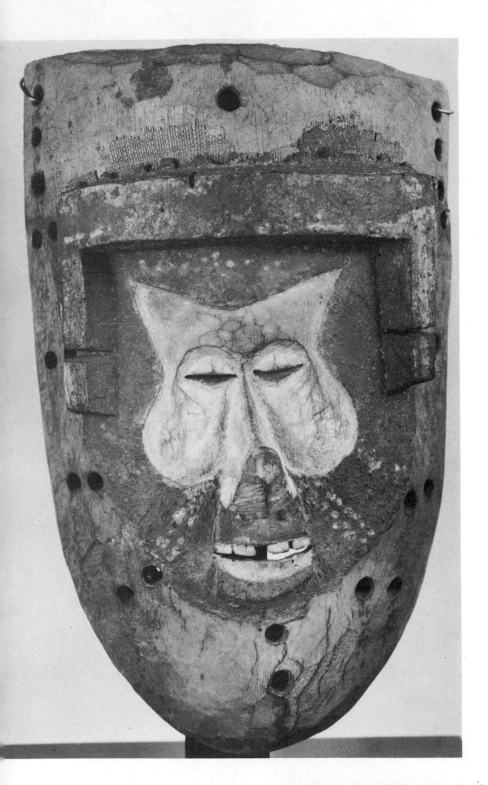

142. Mask. Bayaka, Belgian Congo. 9″ high.

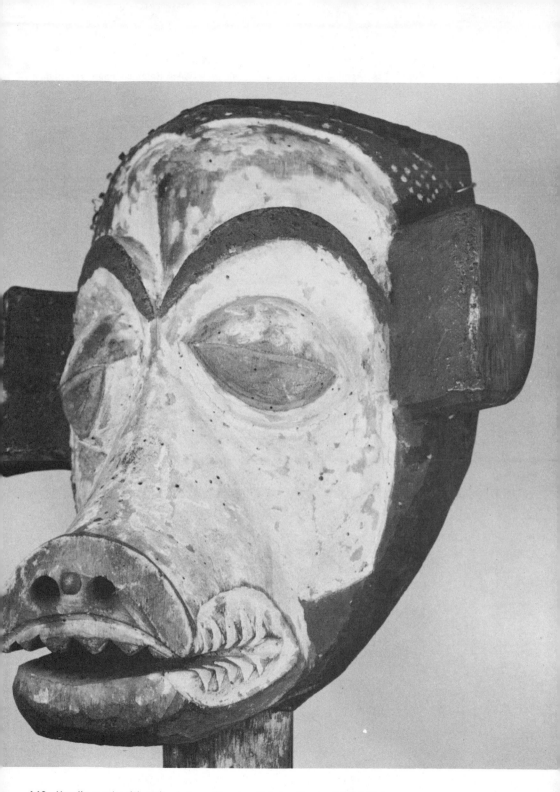

143. Handle-mask with animal nose. Bayaka, Belgian Congo. 13½″ high.

144. Handle-mask with animal nose. Bayaka, Belgian Congo. 12″ high.

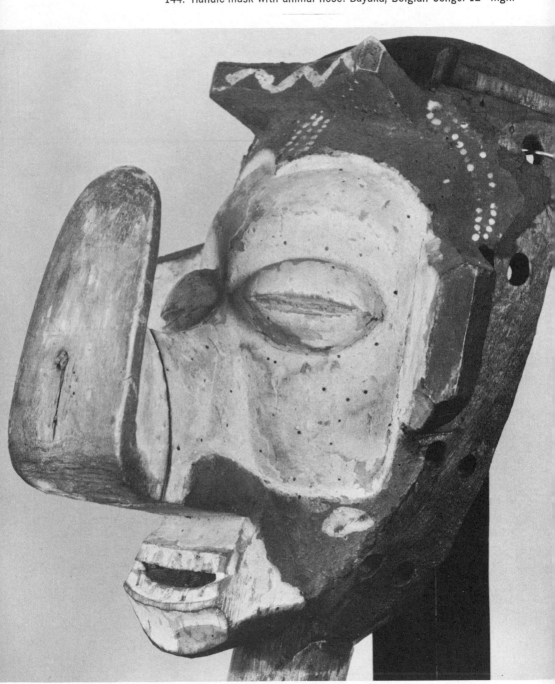

145. Statue. Bayanzi, Belgian Congo. 11″ high.

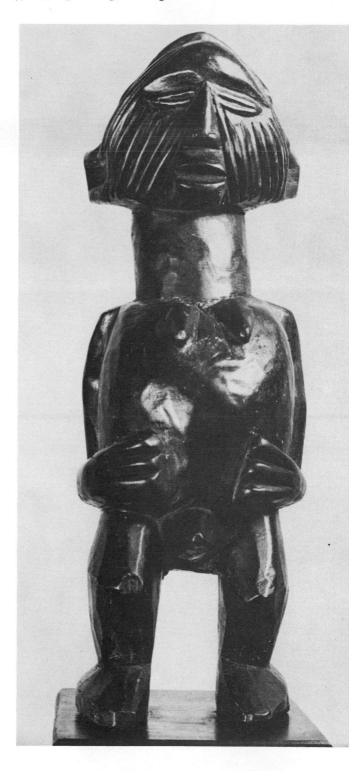

146. Mask. Bena Biombo, Belgian Congo. 14½" high.

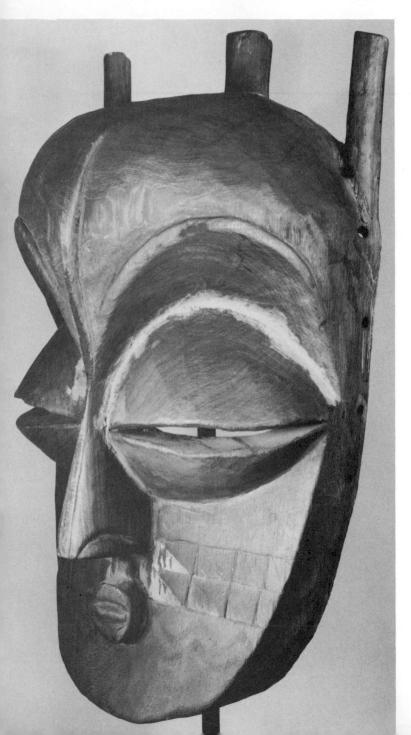

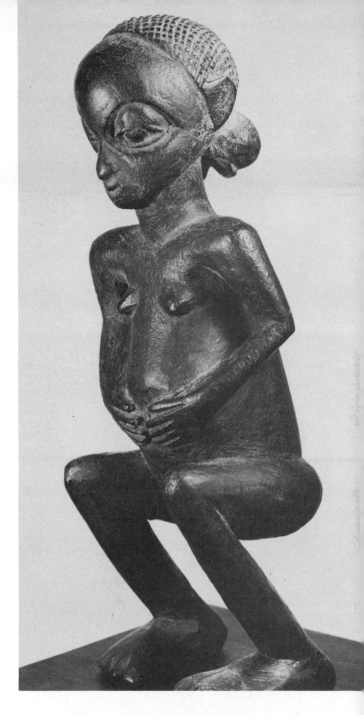

147. Squatting female statue. Bena Kanioka, Belgian Congo. 10″ high.

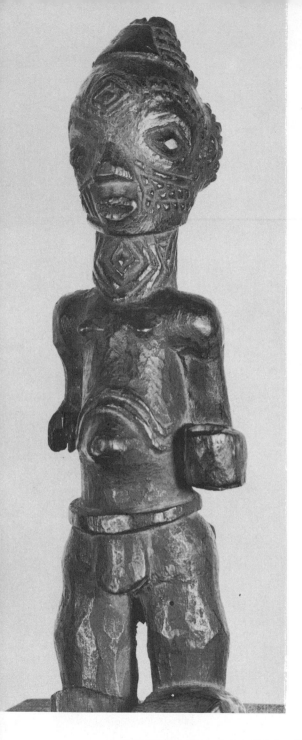

148. Statue. Bena Lulua, Belgian Congo. 8″ high.

149. Statue. Bena Lulua, Belgian Congo. 8½″ high.

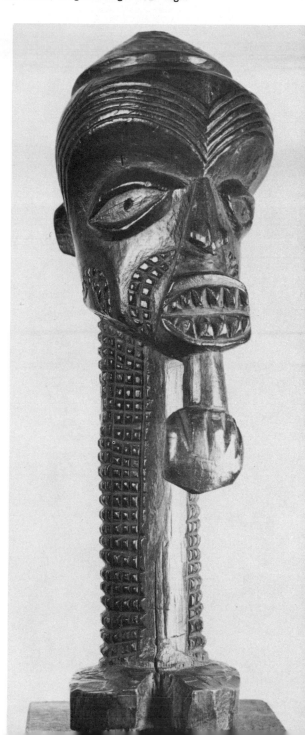

150. Statue. Mangbetu, Belgian Congo. 16″ high.

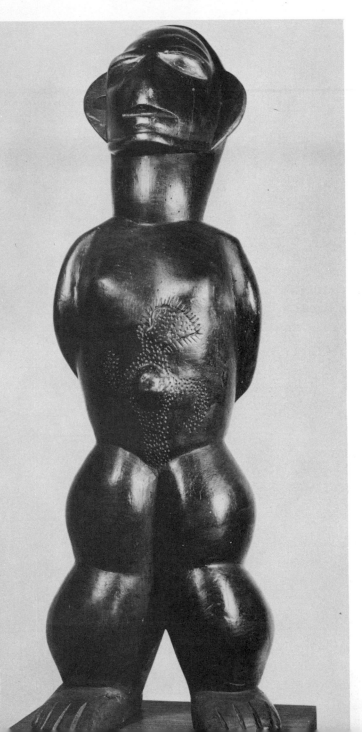

151. Statue. Wabembe, Belgian Congo. 8″ high.

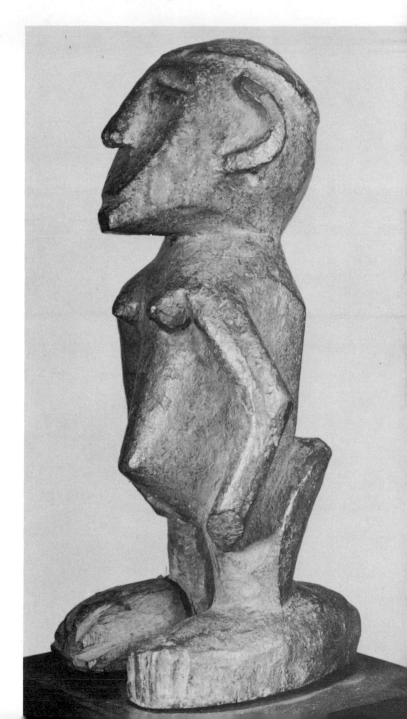

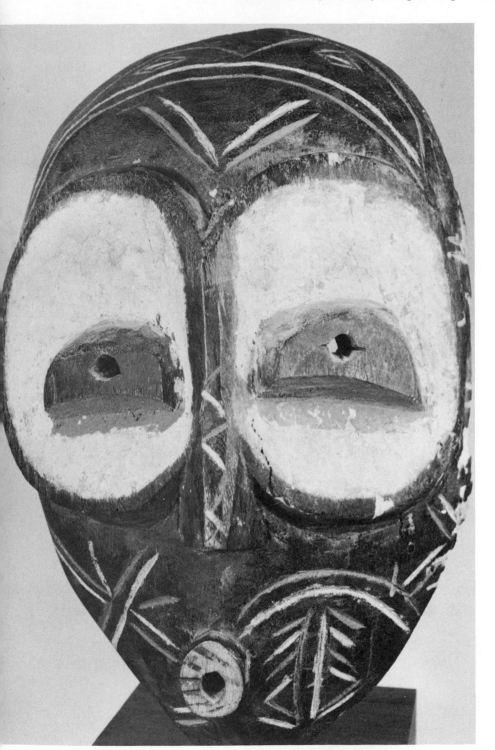

152. Mask. Wagoma-Babuye, Belgian Congo. 11½" high.

153. Statue. Warega, Belgian Congo.

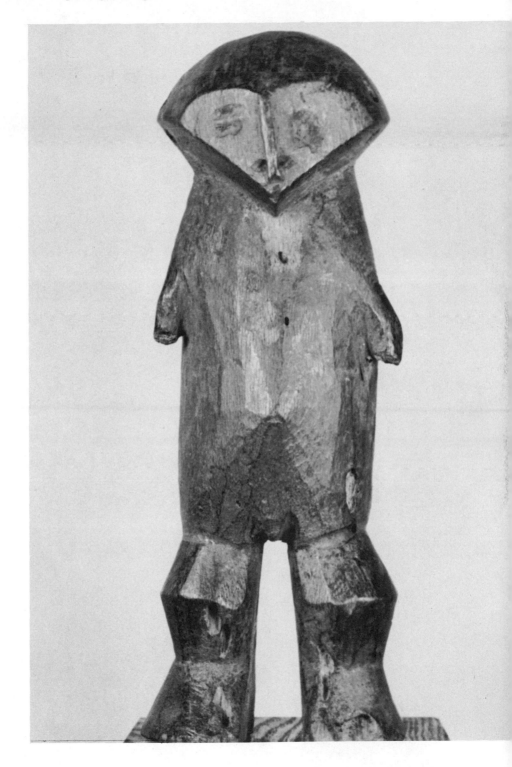

154. Statue. Warega, Belgian Congo. 16″ high.

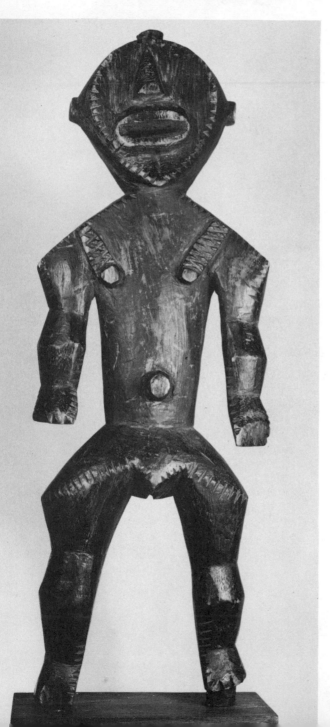

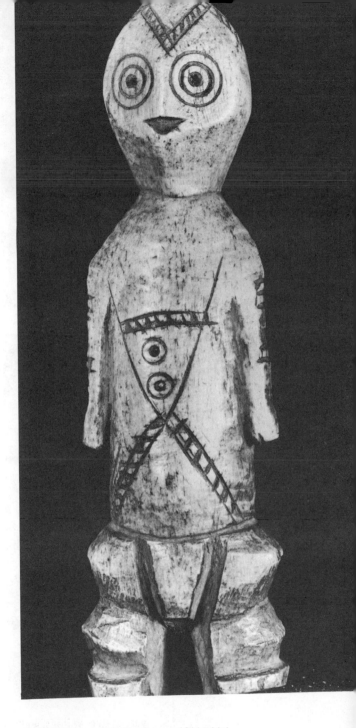

155. Ivory statue. Warega, Belgian Congo. 13½″ high.

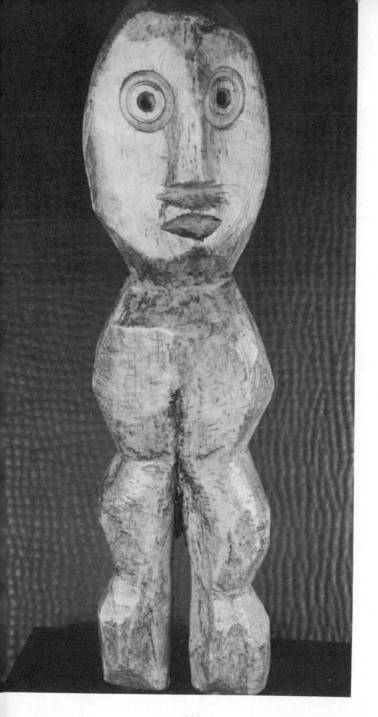

156. Ivory statue. Warega, Belgian Congo. 6″ high.

157. Ivory statue. Warega, Belgian Congo. 5½″ high.

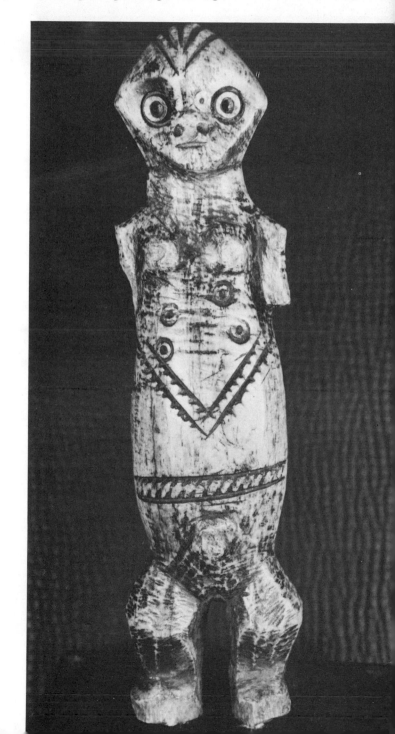

158. Ivory statue. Warega, Belgian Congo. 4½" high.

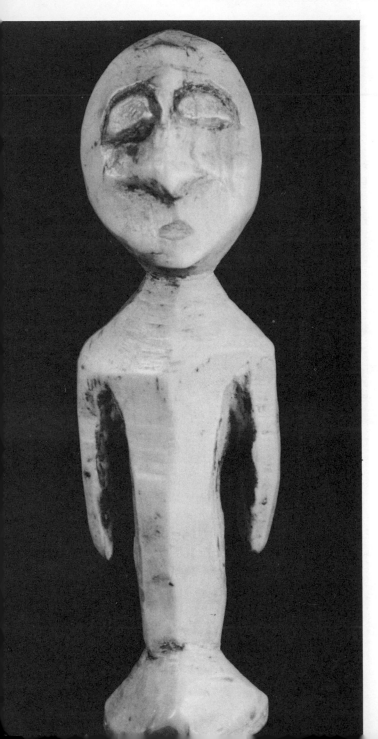

159. Ivory statue. Warega, Belgian Congo. 4½″ high.

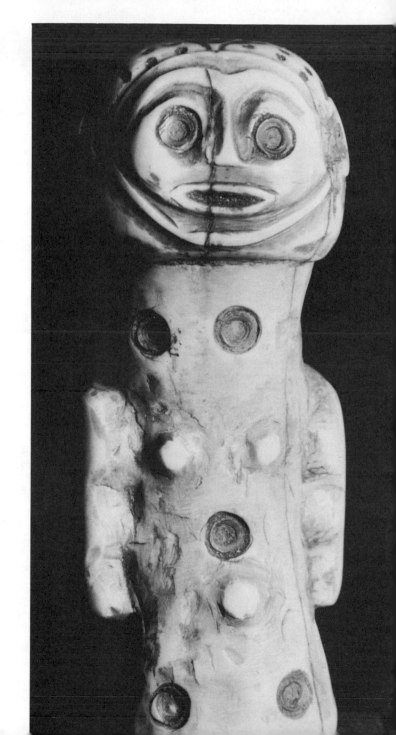

160. Mask. Warega, Belgian Congo. 9″ high.

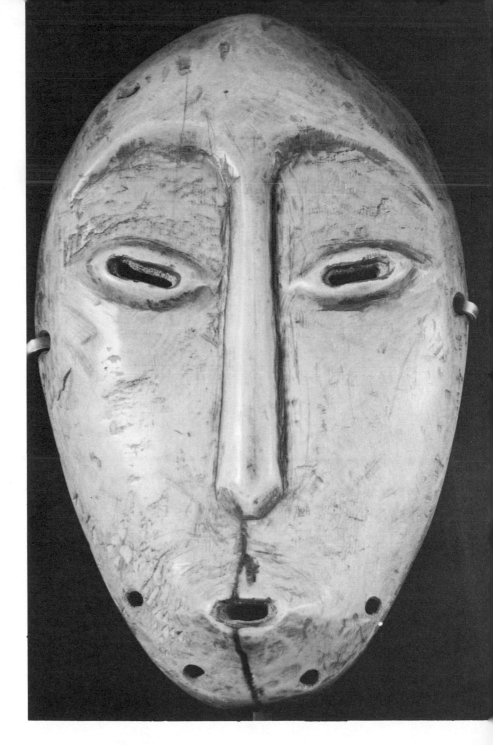

161. Ivory mask. Warega, Belgian Congo. 6″ high.

ANGOLA

162. Stone statue (Mintadi). Region Noqui, Angola. 14″ high.

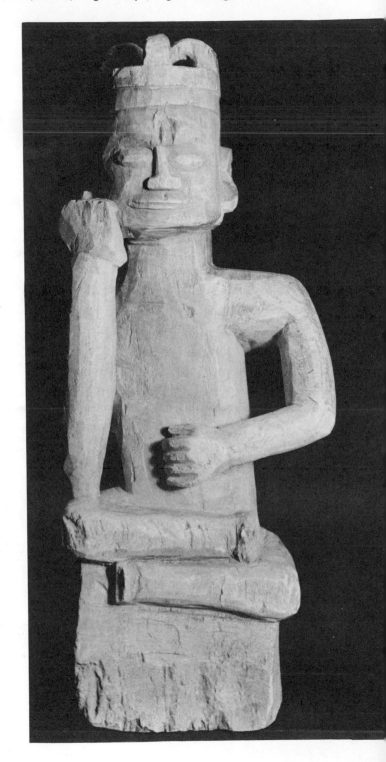

163. Head rest. Makalanga, Mashonaland, Southern Rhodesia. 5″ high.

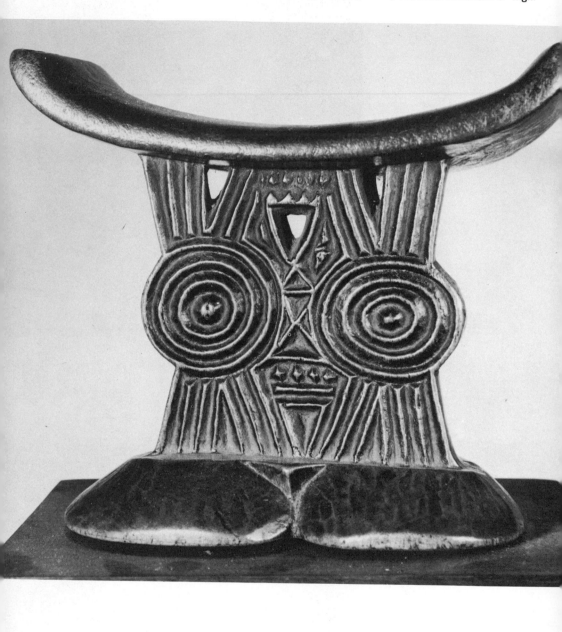

MAP

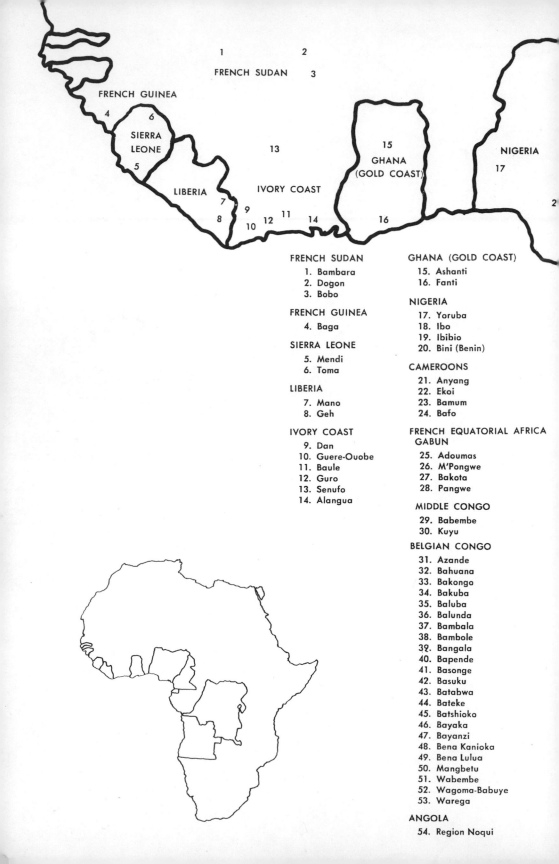

FRENCH SUDAN

FRENCH GUINEA

SIERRA
LEONE

LIBERIA

IVORY COAST

GHANA
(GOLD COAST)

NIGERIA

FRENCH SUDAN
1. Bambara
2. Dogon
3. Bobo

FRENCH GUINEA
4. Baga

SIERRA LEONE
5. Mendi
6. Toma

LIBERIA
7. Mano
8. Geh

IVORY COAST
9. Dan
10. Guere-Ouobe
11. Baule
12. Guro
13. Senufo
14. Alangua

GHANA (GOLD COAST)
15. Ashanti
16. Fanti

NIGERIA
17. Yoruba
18. Ibo
19. Ibibio
20. Bini (Benin)

CAMEROONS
21. Anyang
22. Ekoi
23. Bamum
24. Bafo

FRENCH EQUATORIAL AFRICA GABUN
25. Adoumas
26. M'Pongwe
27. Bakota
28. Pangwe

MIDDLE CONGO
29. Babembe
30. Kuyu

BELGIAN CONGO
31. Azande
32. Bahuana
33. Bakongo
34. Bakuba
35. Baluba
36. Balunda
37. Bambala
38. Bambole
39. Bangala
40. Bapende
41. Basonge
42. Basuku
43. Batabwa
44. Bateke
45. Batshioko
46. Bayaka
47. Bayanzi
48. Bena Kanioka
49. Bena Lulua
50. Mangbetu
51. Wabembe
52. Wagoma-Babuye
53. Warega

ANGOLA
54. Region Noqui

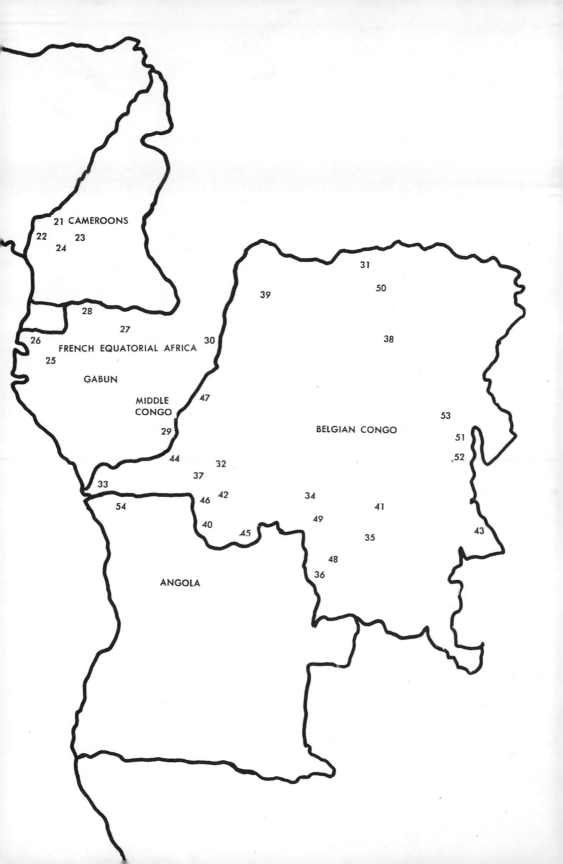

21 CAMEROONS

22

23

24

28

27

26

FRENCH EQUATORIAL AFRICA

25

GABUN

MIDDLE
CONGO

30

39

31

50

38

47

29

BELGIAN CONGO

53

51

.52

44

32

37

33

42

46

34

41

43

54

49

40

45

35

ANGOLA

48

36

The African sculptures illustrated in this volume are from the Segy Gallery, New York, with the following exceptions: Mr. and Mrs. J. W. Alsdorf, No. 48; Mr. and Mrs. Mel Boldt, No. 75; Mr. and Mrs. Morgan Butler, Jr., No. 65; Mr. John E. Coleman, No. 118; Mrs. Lucille Curlee, No. 33; Mr. and Mrs. G. C. K. Dunsterville, No. 22; Mr. Scott Johnston, No. 42; Mr. and Mrs. Isidor Kahane, Nos. 99, 100; Mr. and Mrs. John Kanelous, No. 32; Mr. and Mrs. Jacques Lipchitz, Nos. 61, 159; Mr. Jerrold Loebl, No. 11; Mr. and Mrs. Fred Olsen, No. 12; Mr. and Mrs. Michael M. Rea, No. 121; Mr. Harold Reynolds, No. 31; Mr. and Mrs. Henry Rogers, No. 71; Mr. and Mrs. Edouard Sandoz, No. 26; Dr. and Mrs. Mortimer Shapiro, No. 106; Miss Carol Silver, No. 36; Mr. and Mrs. Clark Stillman, Nos. 85, 105, 128, 132, 134, 141, 147, 148; Mr. and Mrs. William Tarr, No. 145; Dr. and Mrs. James Toolan, No. 129; The Wellcome Historical Museum, London, No. 18; Mr. and Mrs. Raymond Wielgus, Nos. 3, 39, 45, 466 52, 67, 101, 113, 114, 120, 153; Dr. S. N. Wollf, Nos. 35, 137.

LADISLAS SEGY

A native of Hungary, Mr. Segy resided in Paris for 18 years, where he was known for his own paintings and as a collector of modern French and African art. An art critic as well, he was in close contact with the masters of the Ecole de Paris.

By 1932 his collection of African sculpture was widely recognized as one of the finest and most comprehensive in the world, and was exhibited in European capitals a number of times. He has maintained this leadership since his arrival in America in 1936, and has become one of the acknowledged experts in the field.

Mr. Segy's first book AFRICAN SCULPTURE SPEAKS attained a large audience in 32 countries. One of the finest works directing our attention to the treasures of African art, it was also one of the most enthusiastically acclaimed. This volume was followed by AFRICAN ART STUDIES, a selection of fourteen scholarly papers which had been published in various journals over a period of years.

Mr. Segy has published in scholarly journals over 30 papers in 6 languages and has contributed articles on African art to the ENCYCLOPAEDIA BRITANNICA. A member of American, British, and French learned societies, in 1953 he was awarded an honorary degree of Doctor of Letters. In 1950 he established the Segy Gallery in New York City, which has since become known as one of the most comprehensive private collections of African art.

A FEW BOOKS ON AFRICAN ART
available in English

Griaule, Marcel, *Folk Art of Black Africa*. New York, 1950.

Kjersmeier, Carl, *African Negro Sculpture*. New York, 1948.

Radin, Paul and Sweeney, James Johnson, *African Folktales and Sculpture*. New York, 1952.

Schmalenbach, Werner, *African Art*. New York, 1954.

Segy, Ladislas, *African Sculpture Speaks*. New York, 1952. (Second Printing 1955.)

Segy, Ladislas, *African Art Studies, Vol. 1*. New York, 1956.

Trowell, Margaret, *Classical African Sculpture*. New York, 1954.

Underwood, Leon, *Figures in Wood of West Africa*. London, 1947.

Underwood, Leon. *Masks of West Africa*. London, 1948.

Underwood, Leon, *Bronzes of West Africa*. London, 1949.

Wingert, Paul S., *The Sculpture of Negro Africa*. New York, 1950.

Dover Books on Art

THE COMPLETE BOOK OF SILK SCREEN PRINTING PRO-DUCTION, J. I. Biegeleisen. Here is a clear and complete picture of every aspect of silk screen technique and press operation—from individually operated manual presses to modern automatic ones. Unsurpassed as a guidebook for setting up shop, making shop operation more efficient, finding out about latest methods and equipment; or as a textbook for use in teaching, studying, or learning all aspects of the profession. 124 figures. Index. Bibliography. List of Supply Sources. xi + 253pp. 5⅜ x 8½.

21100-2 Paperbound $2.75

A HISTORY OF COSTUME, Carl Köhler. The most reliable and authentic account of the development of dress from ancient times through the 19th century. Based on actual pieces of clothing that have survived, using paintings, statues and other reproductions only where originals no longer exist. Hundreds of illustrations, including detailed patterns for many articles. Highly useful for theatre and movie directors, fashion designers, illustrators, teachers. Edited and augmented by Emma von Sichart. Translated by Alexander K. Dallas. 594 illustrations. 464pp. 5⅛ x 7⅛.

21030-8 Paperbound $3.00

CHINESE HOUSEHOLD FURNITURE, G. N. Kates. A summary of virtually everything that is known about authentic Chinese furniture before it was contaminated by the influence of the West. The text covers history of styles, materials used, principles of design and craftsmanship, and furniture arrangement—all fully illustrated. xiii + 190pp. 5⅝ x 8½.

20958-X Paperbound $1.75

THE COMPLETE WOODCUTS OF ALBRECHT DURER, edited by Dr. Willi Kurth. Albrecht Dürer was a master in various media, but it was in woodcut design that his creative genius reached its highest expression. Here are all of his extant woodcuts, a collection of over 300 great works, many of which are not available elsewhere. An indispensable work for the art historian and critic and all art lovers. 346 plates. Index. 285pp. 8½ x 12¼.

21097-9 Paperbound $3.00

Dover publishes books on commercial art, art history, crafts, design, art classics; also books on music, literature, science, mathematics, puzzles and entertainments, chess, engineering, biology, philosophy, psychology, languages, history, and other fields. For free circulars write to Dept. DA, Dover Publications, Inc., 180 Varick St., New York, N.Y. 10014.